Exhibition-*ism*: Museums and African Art

Exhibition-*ism*: Museums and African Art

Mary Nooter Roberts
Susan Vogel

in collaboration with
Chris Müller

With quotations from discussions with:
Michael Brenson, James Clifford, John Conklin, Arthur Danto,
Maureen Healy, Ivan Karp, Barbara Kirshenblatt-Gimblett
and Maya Lin.

and from participants in the Museum's symposium
"Africa by Design: Designing a Museum for the 21st Century":
Ayuko Babu, Carol Duncan, Ekpo Eyo, dele jẹgẹdẹ,
Labelle Prussin, Jean-Aimé Rakotoarisoa, Enid Schildkrout,
Robert Farris Thompson, and Fred Wilson

The Museum for African Art, New York

EXHIBITION-ism: Museums and African Art is published in conjunction with an exhibition of the same title organized and presented by The Museum for African Art, New York.

Text Editor: David Frankel
Design: Linda Florio Design
Design Assistant: Nadia Coën
Publication Coordinator: Elizabeth Bigham

Library of Congress catalogue card no. 94-78064
Paperbound ISBN 0-945802-16-1

Cover. Background: Chris Müller, floor plan for installation of "Exhibition-ism." Far left: Akan royal procession, Ghana. Photograph by Susan Vogel. Left: power figure, Kongo, Zaire. Collection Renée and Chaim Gross Foundation. Photograph by Jerry L. Thompson. Right: Kongo figures displayed in the Center for African Art exhibition "Africa Explores: 20th Century African Art, " 1991. Photograph by Jerry L. Thompson.

Printed and bound in Japan.

Contents

Current Donors

Mr. Henry van Ameringen
Mr. Charles Benenson
Mr. & Mrs. Richard Faletti
Mr. Lawrence Gussman
Jane & Gerald Katcher
Mr. & Mrs. Lee Lorenz
Drs. Marian & Daniel Malcolm
Adriana & Robert Mnuchin
Mr. Don Nelson
Mr. & Mrs. James J. Ross
Lynne & Robert Rubin
Daniel Shapiro & Agnes Gund
Cecilia & Irwin Smiley
Susan Vogel & Kenneth Prewitt
Mr. Jason H. Wright

Mr. & Mrs. Charles Davis
Lance Entwistle
Roberta Entwistle
Mr. & Mrs. Irwin Ginsburg
Mr. Peter Norton
Mr. & Mrs. Morris Pinto

Mr. & Mrs. William Adams
Mr. S. Thomas Alexander, III
Ms. Joan Barist
Dr. Michael Berger
Mr. & Mrs. Joseph Blank
Mr. & Mrs. DuVal Cravens
Dr. & Mrs. Robert Cumming
Mr. & Mrs. Charles Davis
Drs. Nicole & John Dintenfass
Mr. & Mrs. Marc Ginzberg
Dr. & Mrs. John Herlihy
Mr. Daniel Hourde
Mr. Charles Inniss
Mr. & Mrs. Jerome Kenney
Mr. & Mrs. Martin Kimmel
Mr. Lincoln Kirstein
Mr. William F. Kuntz, II
Mr. & Mrs. Jay Last
Mr. & Mrs. Philippe Leloup
Mr. & Mrs. Robert Nooter
Mr. Richard Parsons
Ms. E. Anne Pidgeon
Mr. & Mrs. Roger Prager
Mr. Eric Robertson
Mrs. Harry Rubin
Mr. & Mrs. Edwin Silver
Mr. Merton Simpson
Mr. & Mrs. Saul Stanoff
Mr. Maurice Tempelsman
Mr. Thomas G.B. Wheelock

Mr. Ernst Anspach
Mr. Alan Brandt
Diane Feldman & Frederick Cohen
Ms. Lisa Ely
Mr. Hubert Goldet

Dr. & Mrs. Gilbert Graham
Mr. & Mrs. John Grunwald
Mr. & Mrs. Jacques Hautelet
Mr. Udo Horstmann
Mr. & Mrs. Stephen Humanitzki
Mr. Harry Kavros
Mr. Oumar Keinde
Mr. & Mrs. Barry Kitnick
Mr. Stanley Lederman
Mr. & Mrs. Sol Levitt
Mr. & Mrs. Brian Leyden
Mr. & Mrs. Thomas Marill
Mr. Barry Maurer
Ms. Sally Mayer
Mrs. Kendall Mix
Kathy van der Pas & Steven van
 de Raadt
Mr. & Mrs. Fred Richman
Mr. & Mrs. Milton Rosenthal
Mr. & Mrs. Herbert Schorr
Mr. & Mrs. Jerome Siegel
Mr. & Mrs. Morton Sosland
Mr. Gerard Tate
Mr. Nils von der Heyde
Dr. & Mrs. Bernard Wagner
Mr. & Mrs. William Ziff

Mr. & Mrs. Barry Adams
Monni Adams
Ms. Marcelle S. Akwei
Mr. & Mrs. Arnold Alderman
Ms. Susan Allen
Mr. Pierre Amrouche
Sandy Baker & Siliki Fofana
Mr. Neal Ball
Ms. Audreen Ballard
Mr. Walter Bareiss
Mrs. Saretta Barnet
Mr. Thomas F. Barton
Mr. & Mrs. Armand Bartos
Mr. & Mrs. Robert Benton
Dr. & Mrs. Samuel Berkowitz
Mr. & Mrs. Sid Berman
Mr. & Mrs. Joseph Blank
Mr. Lawrence Block
Ms. Jean Borgatti & Donald Morrison
Mr. & Mrs. Martin Bresler
The Reverend &
Mrs. Raymond Britt
Mr. & Mrs. John Buxton
Ms. Joyce Chorbajian
Mr. & Mrs. Carroll Cline
Dr. & Mrs. Oliver Cobb
Mr. Jeffrey Cohen
Mr. & Mrs. Alan Cohn
Mr. Herman Copen
Ms. Lisa Cortes
Ms. Farah Damji
Mr. Rodger Dashow
Mr. & Mrs. Edward De Carbo

Mr. & Mrs. Kurt Delbanco
Mr. & Mrs. Jeff Dell
Jill & Ray Dempsey
Dr. D. David Dershaw
Mr. Sulaiman Diane
Mr. Morton Dimondstein
Mr. & Mrs. Alan Dworsky
Ms. Barbara Eisold
Drs. Jean & Noble Endicott
Dr. & Mrs. Aaron Esman
Mr. John Falcon
Mr. & Mrs. George Feher
Mr. & Mrs. Lincoln Field
Mr. Charles Flowers
Mr. Jeremiah Fogelson
Mr. Gordon Foster
Mr. Charles Frankel
Mr. & Mrs. Marc Franklin
Dr. Murray Frum
Dr. & Mrs. Joel Fyvolent
Ms. Clara Gebauer
Ms. Marianne Geschel
Mr. Robert A. Gerard
Ms. Emily G. Gittens
Mr. & Mrs. Joseph Goldenberg
Ms. Susan Gordy
Dr. & Mrs. Irwin Gross
Mr. & Mrs. Tyrone Harley
Mr. Stephen Heard
Dr. & Mrs. Michael Heymann
Ms. Elizabeth Hird
Mr. Charles B. Hobson
Mr. David Holbrook
Mr. & Mrs. Bernard Jaffe
Mr. & Mrs. Harmer Johnson
Ms. Lucy Johnson
Mr. Jerome Joss
Margaret Kaplan
Ms. June Kelly
Mr. & Mrs. Joseph Knopfelmacher
Ms. Ida Kohlmeyer
Mr. Werner Kramarsky
Mr. John Kunstadter
Mr. & Mrs. Bernard Kushner
Mr. Alvin S. Lane
Mr. & Mrs. Guy Lanquetot
Mr. & Mrs. Seymor Lazar
Mr. Jay C. Leff
Ms. Lydia Lenaghan
Mr. & Mrs. Samuel Lurie
Joanne & Lester Mantell
Mr. & Mrs. Thomas Marill
Mr. & Mrs. Lloyd McAulay
The Honorable John A. McKesson
Ms. Genevieve McMillan
Mr. & Mrs. Robert E. Meyerhoff
Mr. Thando Mhlambiso
Ms. Marguerite Michaels
Mr. & Mrs. Peter Mickelsen
Mr. Sam Scott Miller

Ms. Elaine Mintzer
Mr. & Mrs. Donald Morris
Dr. Werner Muensterberger
Mr. & Mrs. Daniel Murnick
Mr. Thomas Murray
Mr. Charles J. Mus
Ms. Judith Nash
Mr. D. Nathan-Maister
Mr. & Mrs. Milford Nemer
Mr. & Mrs. Roy Neuberger
Mr. & Mrs. Herbert Neuwalder
Mr. Michael Oliver
Mr. Michael Ovitz
Ms. Carolyn Owerka & Alyasha
 Owerka-Moore
Mr. David Owsley
Mr. & Mrs. Stuart Paley
Professor & Mrs. John Pemberton
Mr. Klaus Perls
Ms. Linda C. Phillips
Ms. E. Anne Pidgeon
Mr. & Mrs. Jonathan Plutzik
Mr. & Mrs. Joseph Pulitzer
Ms. Carol L. Putzel
Mr. & Mrs. George Rickey
Ms. Beatrice Riese
Ms. Flavia Robinson
Ms. Betty J. Roemer
Lori & William Roseman
Mr. & Mrs. Marvin Ross-Greifinger
Ms. Ana Roth & Abraham Vortster
Mr. & Mrs. William Roth
Mr. & Mrs. Philip Rothblum
Ms. Barbara Rubin
Mrs. Stephen Rubin
Mr. William Rubin
Mr. Michael Sand
Mr. & Mrs. Arthur Sarnoff
Mr. Stephen K. Scher
Mrs. Franyo Schindler
Mr. Sydney Shaper
Mr. & Mrs. Gerald Shapiro
Mr. & Mrs. Ralph Shapiro
Ms. Mary Jo Shepard
Mr. & Mrs. Henricus Simonis
Mr. & Mrs. Kenneth Snelson
Richard Solomon & Lisa Bradley
Carol Spindel & Tom Bassett
Ms. Barbara H. Stanton
Ms. Patricia E. Steed
Dr. & Mrs. Donald Stewart
Naomi & John Tamerin
Mr. Howard Tanenbaum
Ellen & Bill Taubman
Mr. Farid Tawa
Mr. & Mrs. William Teel
Ms. Gloria P. Turner
Dr. & Mrs. Saul Unter
Ms. Carolyn Carter Verleur
Mr. & Mrs. Anthony Viscusi

Foreword:
Ten Years of Exhibitions

In 1988, one of the Museum for African Art's most acclaimed exhibitions opened in Dallas, and was greeted by this review:

> **Art with no Gestalt: Contrivance Overwhelms African Exhibit.** One of the most contrived exhibits ever to appear here opened this week. . . .
>
> "ART/artifact" bypasses the traditional role of museum exhibits—to present great art to the public as such—and focuses instead on the psychology behind displaying objects.
>
> The exhibition sets out to explain how Westerners have come to regard African objects as art rather than artifacts. The implication is that the change in point of view is largely a result of the ways in which African objects have been displayed during this century. . . .
>
> For those determined enough to look *at* the art rather than *into* the viewing process, the . . . exhibit has more than enough quality items to satisfy even the most discriminating tastes. But wading through the installation is tough going". – Janet Kutner, in *The Dallas Morning News*, 26 November 1988.

Since the Museum's founding ten years ago, the assumption that museum-goers can merely look *at* African works of art—as if, in order to see them, we didn't have to look *into* and through the quite specific contexts in which they are exhibited—has

been increasingly disputed. African art's exhibition in the West is not that simple. In a sense, the "traditional role of museum exhibits" described by the Dallas critic—to "present great art to the public as such"—is not yet within the reach of a museum of African art. Her point of view is noted, however, and is surely shared by many of our visitors and supporters. Art objects remain the central raison d'être of the Museum for African Art, the heart of our fascination; but as we look at them, the question of how that act of looking is enacted has become an inescapable one.

African art has been exhibited *as art* in America for exactly eighty years. The theories expressed by those exhibition installations, and the practices they embodied, remained relatively constant for about seventy of those years, then began to change radically. For earlier generations, "Black Africa" had been an abstraction, a place they had never seen, and its art was presentable only in a distanced, aestheticizing manner. But beginning in the late 1960s, numbers of young researchers in art history and anthropology conducted fieldwork in Africa, living in villages and immersing themselves in the physical and intellectual context of African art. The writers of this catalogue are two of the many who returned to the museum with ideas about presentation profoundly altered by what they had learned and seen. It was no longer possible, they felt, to exhibit the sacred, meaningful objects they had seen in Africa as inert, frozen forms. It had become imperative to contextualize and explain African art and beliefs to the wider public.

The meanings of the artworks in Africa were multiple and open to debate, however, as were the methods of contextualizing them in museums. Both these arenas still demand research and investigation today.

"Exhibition-*ism*" is one such investigation, an exhibition that mirrors the process of conceiving and constructing an exhibition. A complementary one is this book with its many voices, rephrasing, asserting, and contradicting. The authors bring their distinct approaches to the problem of the joint show that they have discussed and developed together. In addition, colleagues within and outside the Museum lend their own perspectives to the exhibition problem and to larger issues that the Museum faces. The resulting book is repetitious in part because different minds are focused on a related series of problems.

The authors' interests focus on art in Africa, and on the museum installation of African art. The many political and social issues bearing on the display of African

art in the West are barely mentioned here. Also missing from this catalogue are the art objects in "Exhibition-*ism*." They are drawn mainly from past exhibitions, which is why they are not illustrated here.

The conversations and interactions that go into the making of an exhibition are among the most exciting stages in a museum's life. "Exhibition-*ism*" has been an especially interesting project because it provoked discussion with so many exceptional people. Here, we lay our behind-the-scenes conversations out under the spotlights of the exhibition and book. We wish to thank all the colleagues who allowed us to quote observations they made as participants in the Museum's 1992 symposium "Africa by Design: Designing a Museum for the 21st century," and those who allowed us to tape-record interviews in the spring of 1994. The ideas that came out of this process reinforced our conviction that issues raised by museums and African art stand at the nexus of some of the most compelling issues in contemporary culture today.

Once again, it is only through the commitment and efficiency of the staff of the Museum for African Art that "Exhibition-*ism*" has come into being. Carol Braide transcribed the symposium proceedings and the interviews, and attacked all phases of the catalogue production with zest. Patricia Blanchet, Troy Browne, Marjorie Ransom, June Gaddy, Lubangi Muniania, Carol Thompson, Eliot Hoyt, Erica Blumenfeld, Patrice Cochran, and Tajudeen Raji all played significant parts in the project's completion. Besides overseeing public relations, Paula Webster contributed valuable suggestions to the exhibition.

Once again, we are grateful to Linda Florio for her creative handling of the book and of the exhibition's graphic aspects, despite the growing dimensions of a competing project, and to David Frankel, for his firm yet gentle editorial hand. Assistant Curator Elizabeth Bigham effectively and imaginatively oversaw all aspects of the book, and helped with the formulation of the installation.

Mary Nooter Roberts wishes to give special thanks to the students in her two seminars at Columbia University in the spring of 1994, all of whom contributed valuable ideas. She is also grateful to Karen Milbourne for their ongoing dialogue, as well as to New York students Christine J. Walley, Jennifer Kramer, and Cobina Gillitt Asmara for sharing their graduate papers. She especially thanks Laura Scanlon, whose progressive ideas added intellectual and theoretical backbone to the

overall concept. Dr. Roberts also wishes to thank her husband, Dr. Allen F. Roberts, for bringing key sources to her attention, and for helping her to develop many of the ideas presented here. Despite the generosity of these colleagues, any shortcomings in her writing remain her own. She dedicates her writing to Al, Seth, and Avery.

Chris Müller would like to thank his wife, Constance Hoffman, for everything, large and small.Susan Vogel wishes to thank Ivan Karp for reading her chapters with his usual trenchant insight. Their faults are hers, but surely mitigated by his suggestions. She also warmly thanks the lenders to this exhibition and to those of the last decade, who have generously parted with their beloved objects for the benefit of the Museum and the public.

Susan Vogel wishes to thank Ivan Karp for reading her chapters with his usual trenchant insight. Their faults are hers, but surely mitigated by his suggestions. She also warmly thanks the lenders to this exhibition and to those of the last decade, who have generously parted with their beloved objects for the benefit of the Museum and the public.

Susan Vogel
Mary Nooter Roberts
Chris Müller

Exhibition-*ism*—The Design Approach

Chris Müller

RATHER THAN BEGINNING WITH A COLLECTION, which one tries to organize into a coherent experience, or a series of objects constellated around a theme, the challenge of this exhibit has been to organize themes and exhibition techniques, into which objects are inserted. Much of the process has involved sitting around imagining things we've always wanted to see in a museum, trying to fulfill a frustrated desire we felt when we attended exhibitions—and to identify for ourselves what the frustrations and satisfactions are of mounting displays.

Interviews and conversations were sources for our ideas. An afternoon spent in the museum's events room with Richard Schechner, with whom I had worked as a set designer, proved very influential. Richard suggested the title of "Exhibitionism," characteristically combining the conceptual and the prurient. He also suggested an exhibition where the visitors might rearrange the objects for the next set of visitors, an idea that has become the final room of our exhibit, where people are invited to write how they would design the space, which will change several times according to their suggestions. Richard's thoughts on the idea of secrecy in the museum setting were very intriguing, particularly as he envisioned a visitor coming into a gallery and being confronted by two entrances, one of which would say it presented "Truth," the other, "Secrets." Through the first door one would find objects displayed in a traditional way, pieces of sculpture in vitrines with brief labels affixed to each.

ARTHUR DANTO: If the object continues to be what it has been—the basic vehicle for art—there's a lot of art that isn't very easily any longer thought of in terms of this view. . . . And it's not easy to think how the museum in the future can host them, in terms of collecting them.

ENID SHILDKRONT: It's very interesting to contrast how "African Reflections" looked and felt at the American Museum of Natural History in New York, and how it felt at the National Museum of African Art in Washington, D.C. . . . In New York it had a kind of warmth, an alive feeling that I personally missed in Washington. In New York it was a show about Africa, and in Washington it was a show about art objects . . .

The difference was a couple of things. One was the way the space was arranged, and another was the use of photographs and sound. In Washington, they eliminated three sound tapes we had strategically placed in the exhibition. In New York, we used photographs as objects and as context, not specifically as information. The designer very cleverly played with altering the size of photographs, so that in some places they worked as a kind of stage setting or diorama; in other cases they were objects in themselves. But people were constantly moving between the experience of the photographs and the experience of looking at the objects in the cases. In Washington, they only saw the objects in cases.

The feedback I've gotten from many people, and my

Visitors taking the second door would find themselves in a dark passage with a long window, a one-way mirror through which they could observe those who had chosen the other passage, wandering from vitrine to vitrine in the other room—the secret revealed being the "backstage" point of view. This was the seed of the idea that became our "What the museum shows/what the museum knows" gallery, where a circle of objects in vitrines face out with traditional labels and typical museum information, while the inside of the ring reveals both the physical "backs" of the objects, the often unintended view, as well as information that undermines or contradicts that given on the labels in the front.

One comes to a museum expecting to see beautiful things displayed in an attractive manner, and I have no especial desire to inhibit that expectation. The hope is that during the experience of viewing the objects on display in the museum, the visitor's idea of what is beautiful will expand.

We have had many, many ideas, and I can give an overview of the form the still imaginary exhibit takes in my mind. The differences in what we discuss here and what the visitor will actually walk through reflect the decision-making process of weighing, modifying, and reconsidering at each stage of a process that is usually invisible. A great deal of effort often goes into maintaining the illusion that the form the finished exhibition takes is exactly what was intended all along, unmarred by compromise or indecision. But I take it as a given that however well thought out the concepts and however meticulous the planning, actually setting things up in the gallery space creates a new, wholly unforeseen set of circumstances.

The first gallery, we thought, could be a collage of African images and experiences. Often exhibits that follow the natural history mode try to give some sense of completeness, to hide and smooth over the jagged edges of the discontinuity of the place of the object outside its culture. But collage is the prime twentieth-century art form, and collage acknowledges discontinuity, a new whole made up of several fragments. (Many of these ideas spring from our interview with Barbara Kirshenblatt-Gimblett). The object, say a wooden sculpture, is a fragment of the time and place that produced it, and there are limitations to how much of that time and place can truly be extrapolated from it as it sits in an American art museum, visited by the varied audience of New York City. Should we place it in an environment of other fragments from Africa, coming from other sources and

14

appealing to other senses? Perhaps sounds of Africa, which mean many things—the sounds of the village, the music of dance and ritual, the sound of a meal being eaten, of a car going by, of a plane overhead, of the radio, of a mask being made, of a conversation, of wind blowing through the trees. Smells of Africa—the smell of smoke Susan associates with the Baule villages and African civilization, of food being cooked, of grass, smells that aren't familiar to Americans, or that don't have the same associations they would have for an African, combining to create new associations. The light that shines down on the objects in their display cases might change from the clear even "museum" light, the light of knowledge from above, to the cool light of daylight, to an obscure, changing, partial light that reveals a detail, a fragment of a mask, and then another—the shift from the steady, constant, even, Enlightenment light that illuminated the first ethnographic museums of the 1700s to the theatrical light that obscures and illumines alternately.

Further fragments we thought of using: video as a kind of moving label, small video images the size of a portable hand-held TV, a collage of images combining in a sequence the arc of a displayed object's life—its creation by an artisan, its use in ritual or as a point of offering, its installation in a museum or private home. Other images—bits of public-television-type documentary footage of life in the African village or town, with its mix of the traditional and the new, the raffia costume and the T-shirt, the mud and wattle home and the prefabricated house, the drum and the radio. Objects would be in cases, under Plexiglas, a clean presentation.

We considered confronting the viewer next with a familiar sight in museums, the object behind a barrier, in this case several layers of barriers—a sculpture in a Plexiglas case, behind a velvet-rope stanchion, a guard standing beside, the whole scene swept by surveillance video camera—maybe a closed-circuit television where one can watch oneself watching, seeing the back of one's head as one does in a liquor store similarly equipped; perhaps even the kind of light beam that emits a piercing alarm when broken. A disquieting display of the symbols of curatorial authority and lack of trust, and the piece displayed almost lost in the forest of signs.

Turning the corner past this display, the visitor might meet its antithesis—a series of cubicles, in form resembling a chambered nautilus, to be entered privately. There inside would be a sculpture much like the one just seen in the guarded case, but here unprotected. The visitor could contemplate privately, unself-consciously,

own feeling, is that the exhibition didn't work as well in Washington. So what I'm saying is that it's not simply whether you use Plexi cases or you don't use Plexi cases, but how you think about space, and how you incorporate the Plexi and the other elements—color, visuals, sound—into the experience of the exhibition.

FRED WILSON: This whole notion of not being able to understand the full context that these things are made in or come from—just makes me think of Dan Flavin, who in the 60s made sculpture from fluorescent tubes of various colors . . . and it represented the ultimate in modernity, an ultimate in using things from your environment. And at this stage, twenty years later, you can't even get those tubes . . . because technology has moved along so much, and . . . the relationship between the viewer and the object has changed. . . . There has to be some contextualization of objects and images within a social or political history . . . so that it doesn't get so drawn away from other aspects to create a myth around the object.

15

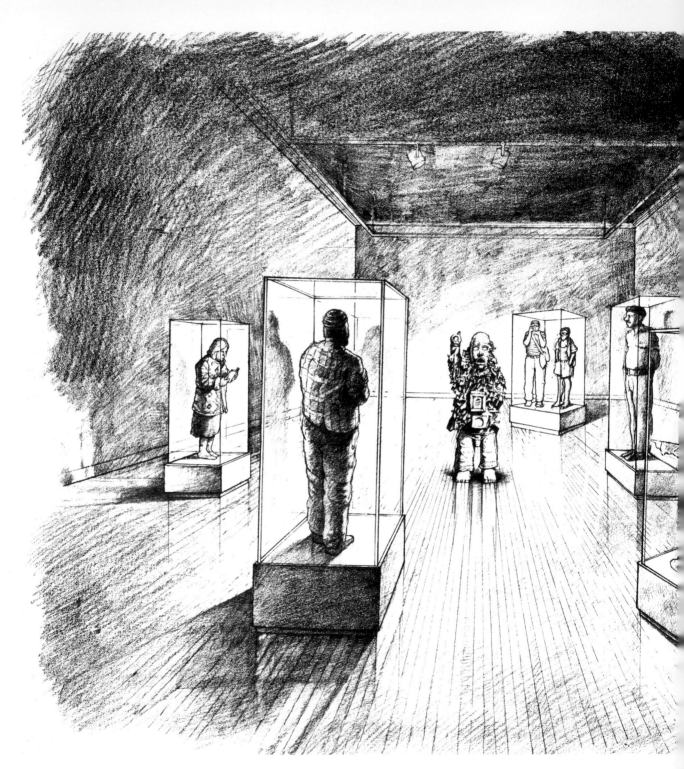

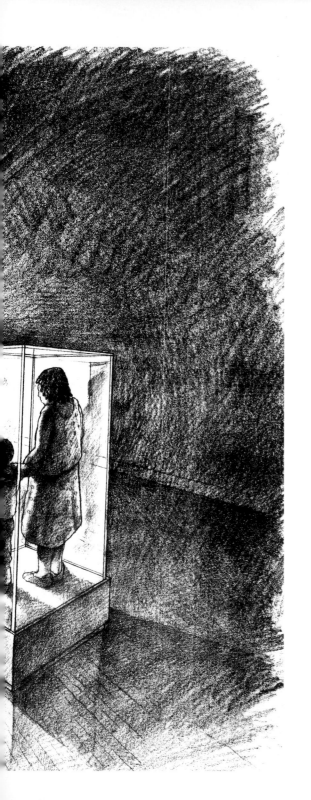

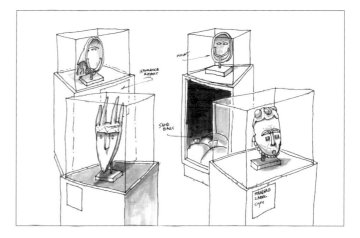

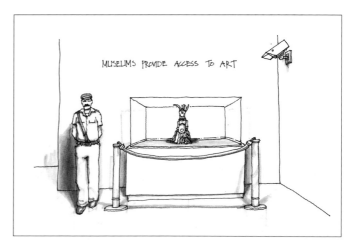

Fig. 1 (left): Hypothetical view of "EXHIBITION-ism.". Sketch by Chris Müller.

Fig. 2 (below): Proposal for Gallery 3. Sketch by Chris Müller.

Fig. 3 (bottom): Proposal for Gallery 2. Sketch by Chris Müller.

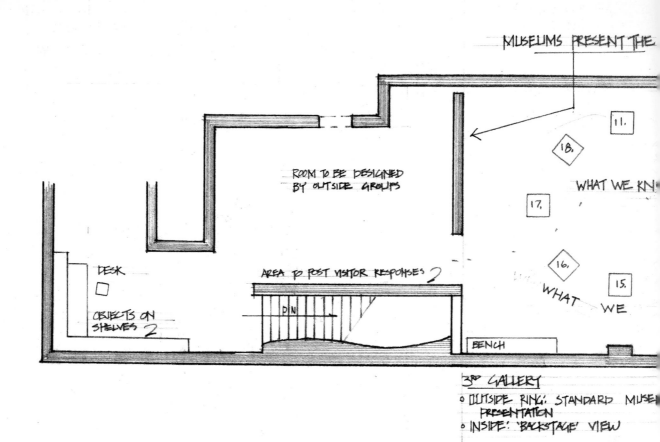

MUSEUMS PRESENT THE

ROOM TO BE DESIGNED
BY OUTSIDE GROUPS

11.

18.

WHAT WE KN

17.

16.

15.

DESK

OBJECTS ON
SHELVES 2

AREA TO POST VISITOR RESPONSES 2

PIN

WHAT WE

BENCH

3RD GALLERY
◦ OUTSIDE RING: STANDARD MUSE
 PRESENTATION
◦ INSIDE: 'BACKSTAGE' VIEW

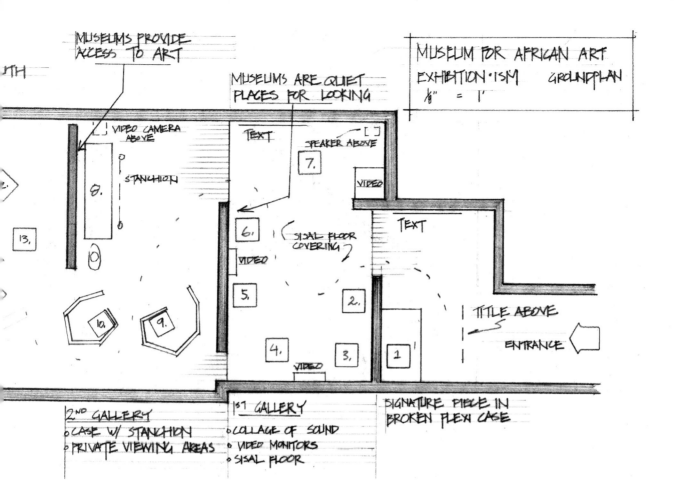

MUSEUMS PROVIDE ACCESS TO ART

MUSEUMS ARE QUIET PLACES FOR LOOKING

MUSEUM FOR AFRICAN ART
EXHIBITION·ISM GROUNDPLAN
⅛" = 1'

LTH

VIDEO CAMERA ABOVE

TEXT

SPEAKER ABOVE

7.

VIDEO

STANCHION

8.

TEXT

13.

6.

SISAL FLOOR COVERING

VIDEO

5.

2.

TITLE ABOVE

ENTRANCE

6.

9.

4.

3.

1

VIDEO

2ND GALLERY
o CASE W/ STANCHION
o PRIVATE VIEWING AREAS

1ST GALLERY
o COLLAGE OF SOUND
o VIDEO MONITORS
o SISAL FLOOR

SIGNATURE PIECE IN BROKEN PLEXI CASE

Figs. 4-5: Ground plans for "Exhibition-ism" by Chris Müller.

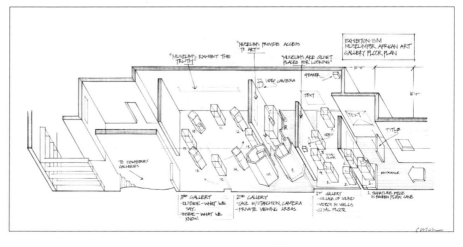

the object and its text. The text, though, would present a further contrast, revealing that in simply seeing this work he or she is transgressing African restrictions. An object may be part of a ritual that is forbidden to uninitiated members, or to the other gender; the freedom to contemplate and gaze in the museum, in the Western tradition, comes at the expense of breaking the taboos of the culture in which the object was born. There are ways, then, in which the sculpture in the guarded case is more "true" to its African origins in terms of its display.

In the next and largest gallery, a dozen or more objects in Plexiglas vitrines would stand in a circle, mostly masks and figurative sculptures facing outward. Circling the cases along the outside perimeter, the visitor would read labels that give the traditional, sober information of the art museum: "Mask. Lega, Zaire. Wood, fiber. Early 20th c. Private collection." Along the inside perimeter, the visitor would see the back view: the masks, roughly carved insides, in Africa seen by the maker and wearer rather than the viewer, as well as the mounts that hold the piece in place for purposes of display. Labels on this side differ from those on the front, their information expanding on those terse captions, or undermining or contradicting them. A question of attribution is aired, a dialogue of disagreement between experts is made public; a piece is revealed to be a fake; an insurance report is shown, the costs associated with its display revealed; the decisions about how to mount and display an object are revealed, with alternative ideas; a damaged piece is assessed; the acquisition of the object, through means more or less fair to the original owner/makers, is discussed.

The final room might begin as "undesigned." The objects, all having in some manner to do with death and its attendant rituals and beliefs, are on shelves, waiting to be arranged in a display. One has always been aware that the major museum institutions have vast collections of which only a slim selection is ever on display; here we might show the museum's reserves. The visitor is invited to consider how they could be displayed in this space: what objects to choose from those in the shelves, how to arrange them, what information to give, what sort of mood and atmosphere to create. Their responses can be recorded and left for others to read, and some are chosen to be carried out—one can return to the room and see the display change.

Museums present work in a static way that, while bringing into focus the formal qualities of a work of art, erases the making of that object. The method of presentation obscures from us the act of creation. The act of moving through the gallery should be a theatrical event, in the sense that the theatrical moment is in the present, now, before you. The object in the museum can reveal to you its life in all its various guises all at once, in an intermingled present. Exhibition-*ism* tries to reconnect the visitor to the act that made an object in the museum, as well as to the act of creating the exhibition itself.

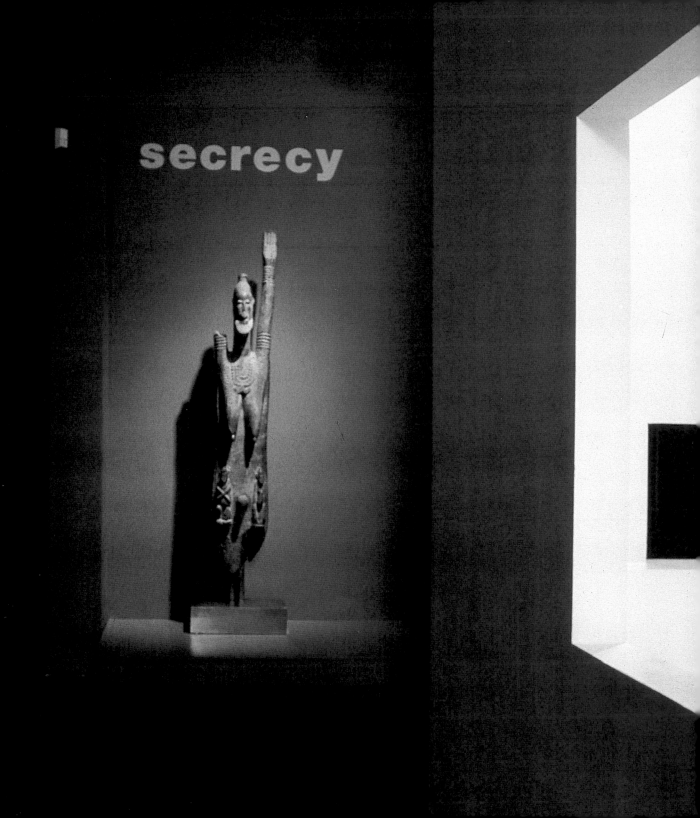

secrecy

Exhibition-*ism*:
Museums and African Art

Mary Nooter Roberts

Introduction: A Museum Questions Itself

What shapes our experience of art—the work itself? Its setting and display? The knowledge we bring to it as viewers? Some combination of these? Do objects reveal their inherent meanings to us, or do we project meanings onto them? Does an exhibition curator impose meaning through presentation? Are objects static, or can their life histories and biographies animate an exhibltion? Are exhibitions mere frames for objects, or do they too have lives of their own?

And what of the museum, which makes new connections for objects, detaching them from their previous settings and embedding them in a new context, the museum itself, where they are made to fit and belong. Where does the museum itself belong? What do we need it for?

With the increasing attention given to questions like these, exhibiting has become an "ism" of the '90s—a politicized terrain, a space of debate, a subject of intellectual and artistic inquiry. The combined message of a number of recent discussions has been that museum presentation is no longer an esoteric subject that matters to specialists only. Curators are examining the signifying process through which museums and exhibitions endow objects with meaning, and exploring the "exhibiting frame" itself as the source of meaning. Museum practice is beginning to be concerned not strictly with "exhibited culture" but also with "exhibition

IVAN KARP: An installatlon is not natural . . . it's man-made . . . a work of art and craft.

Fig. 1 (opposite page): Entrance to "Secrecy: African Art that Conceals and Reveals" showing the Dogon figure that was the exhibition's signature piece, Museum for African Art, 1993. One of the ideas discussed for "Exhibition-ism" was a reinstallation of this exhibition in a different form. Secrecy provides an apt metaphor for exhibiting: like a secret, an exhibition involves a dual process of concealment and revelation. A reinstallation would have been a chance to experiment with the ways different installation techniques alter the message communicated.

culture"—that is, with the values, symbols, and ideas that pervade and shape the practice of exhibiting (Sherman and Rogoff 1994:ix).

Now exhibiting becomes the focus of the Museum for African Art's show "Exhibition-*ism*," an installation that asks audiences to look at the museum itself as a frame, and at the exhibition format as a living, changing entity shaping how we experience and understand aspects of the world. As one of the many contributors to the process of conceptualizing this exhibition writes, "'Exhibition-*ism*' problematizes the act of looking itself. Scrutinizing an isolated object at eye level—that most basic of art-museum behavior—may be inappropriate in African contexts, which rely so often on the nonvisual and the performative. Revealing the museum as a Western institution, the curators and designers of 'Exhibition-*ism*' look to Western theatrical practice as a way of inviting a nonvisual and experiential response from the audience. In reinstalling a number of objects from the Museum's past along with some new ones throughout the galleries, 'Exhibition-*ism*' invites its audience to speak back to its curators."[1] As an occasion to look back and around, to explore exhibiting as a dialogue between object, space, and audience, and to consider the mythos of museums in general, "Exhibition-*ism*" also celebrates the Museum for African Art's tenth anniversary.

In 1992, as the Museum was making the transition from its uptown townhouse on East 68th Street in Manhattan to a new, downtown location in SoHo, a conference was held entitled "Africa by Design: Designing a Museum for the 21st Century." The proceedings were structured to help think through the theoretical issues—political, historical, sociological, aesthetic—that should be addressed in the architecture and design of a small American museum devoted to non-Western art. The participants discussed museum architecture, its silent messages, and the kinds of presentation that can occur within its spaces—issues extending out to problems in the overall Western practice of exhibiting art. They explored how form (the museum's facade and physical structure) and content (the works of art it contains, their presentation, the programs that accompany exhibitions, etc.) are entwined, and discussed the merits of literal versus evocative approaches to architecture and exhibition design. They also explored aspects of architecture and display in indigenous African contexts. What would or should a museum for African art be in the 21st century?

The acts of looking at and producing displays of art have been topics in the Museum's ongoing conversation with its public since it opened in 1984, as the Center for African Art. Its exhibitions have continually reevaluated how museums define their identity, and how they give their audiences access to cultures not their own. Indeed, many of the twenty-two exhibitions produced at the Museum during its first decade—along with accompanying publications, symposia, and public programs—have directly addressed the political and aesthetic implications of presenting African objects in Western museum settings. The foci of these exhibitions have ranged from formal to ethnographic issues, from specific themes within African art to reflexive concerns about how to address such themes. Each exhibition has built on previous ones, creating a narrative of the Museum itself, a lineage and a life history reflecting both the currents of the times and the personal intellectual trajectories of the curators. Taken together, the Museum's exhibitions have challenged assumptions, stereotypes, and misconceptions about Africa and its art, and have invited reflection on the contested boundaries between art and ethnography, authenticity and artifice, earlier and contemporary expressions of culture.

This book and the exhibition it accompanies continue to question not only curatorial authority, exhibition practices, and the politics of displaying the art of non-Western peoples but, more specifically, the ways museum practice conveys meanings and messages (which are often in stark contrast to African perspectives), the limits and possibilities of cross-cultural understanding, and the culturally determined nature of exhibiting as a mode of communication. Like "ART/artifact" (1988), a seminal show in the Museum's history, "Exhibition-*ism*" demonstrates that there is no single, authoritative way to create an exhibition. Inevitably the product of a series of choices made by a given group of people at a particular time and place, an exhibition can clearly be prepared in any number of ways. No presentation is definitive.

Secrecy as a Metaphor for Exhibiting

On a number of levels, the Museum for African Art's first exhibition in its downtown location, "Secrecy: African Art That Conceals and Reveals" (1993) (figs. 1–7), provided apt metaphors for museum practice and experience. It is often a quality of

ROBERT FARRIS THOMPSON: The whole aspiration—and I mean aspiration literally—is a museum that will breathe.

IVAN KARP: Art museum exhibitions are driven by the selection of a hundred great objects. You can't get away from it.

ARTHUR DANTO: There are so many ways these days in which the museum is coming into question, and you've got to define what question it is you want this exhibitive gesture to raise.

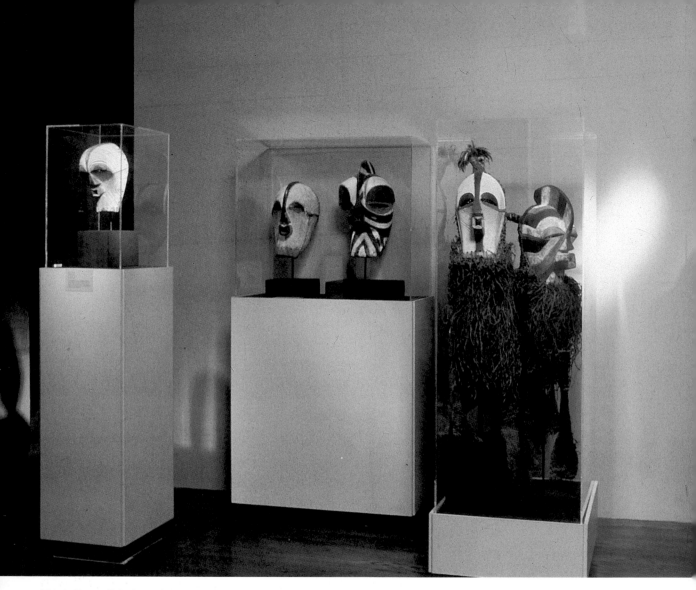

Fig. 2: Songye Kifwebe masks displayed in the section of the "Secrecy" exhibition entitled "How does art conceal and reveal secret knowledge?"

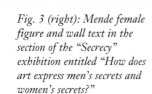

Fig. 3 (right): Mende female figure and wall text in the section of the "Secrecy" exhibition entitled "How does art express men's secrets and women's secrets?"

BARBARA KIRSHENBLATT-GIMBLETT: I like "Exhibition-*ism*" very much . . . because it opens out a whole series of issues that go to making a spectacle of oneself, of exhibiting, of being exhibited, of what it means to show, what it means to be given to be seen. That seems to me to be at the heart of what you're trying to get at.

Fig.4 (following page): Kuba and Bamana textiles, an Ndengese figure, a Luba memory board, and a Bwa plank mask displayed in the section of the "Secrecy" exhibition which explored "the visual language of secrecy".

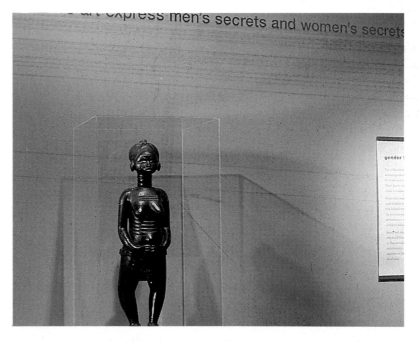

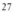

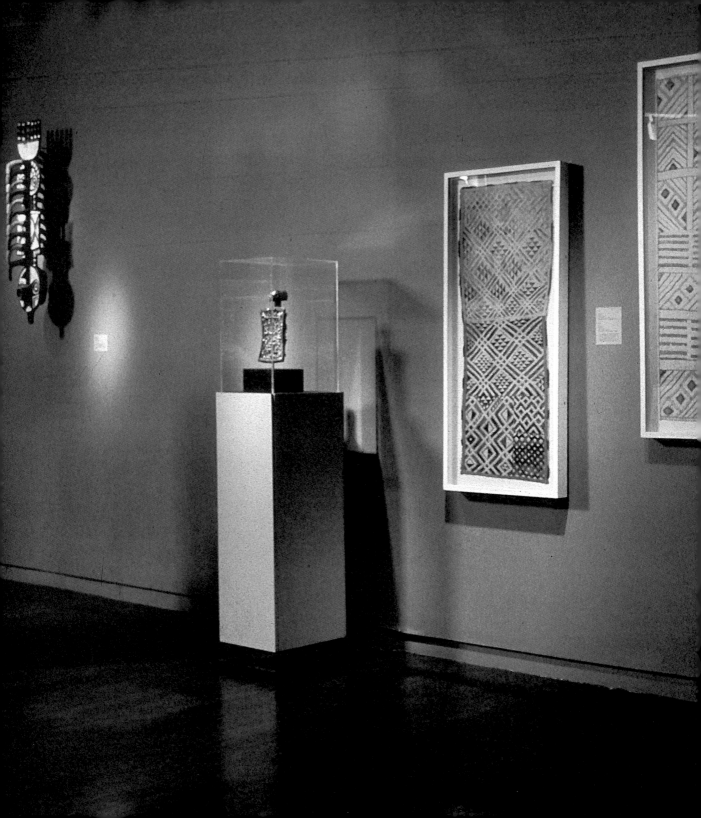

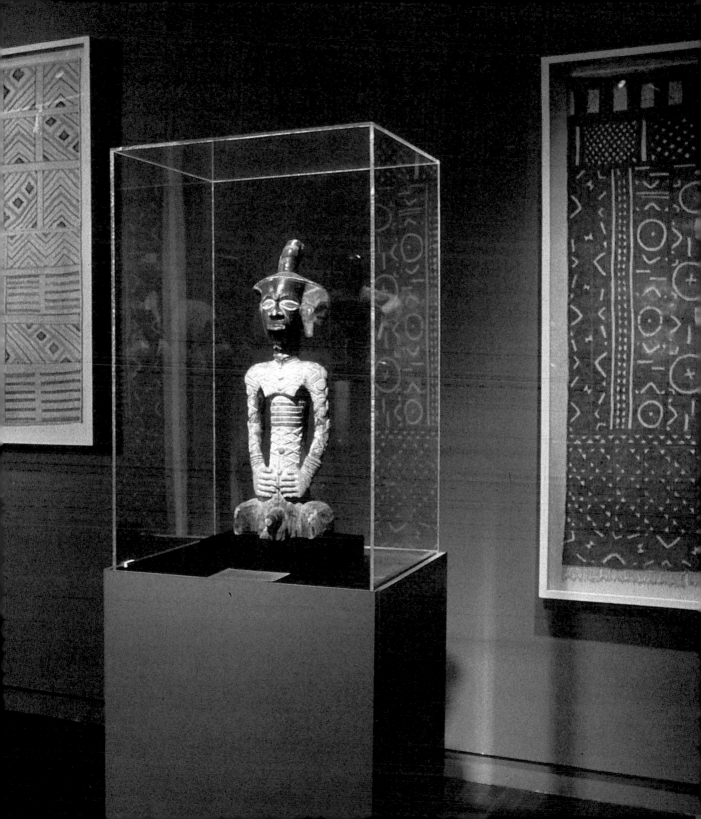

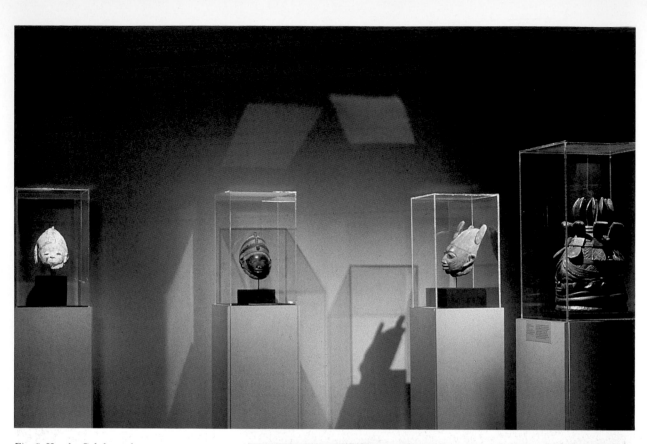

Fig. 5: Yoruba Gelede masks
and a Mende mask in the
section of the "Secrecy"
exhibition entitled "How does
art express men's secrets and
women's secrets?"

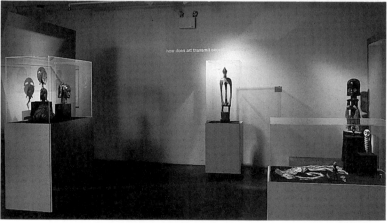

Fig. 6: African objects,
including a Fang figure
and a Senufo rhythm
pounder, in the section of
the "Secrecy" exhibition
entitled "How does
art transmit secret
knowledge?"

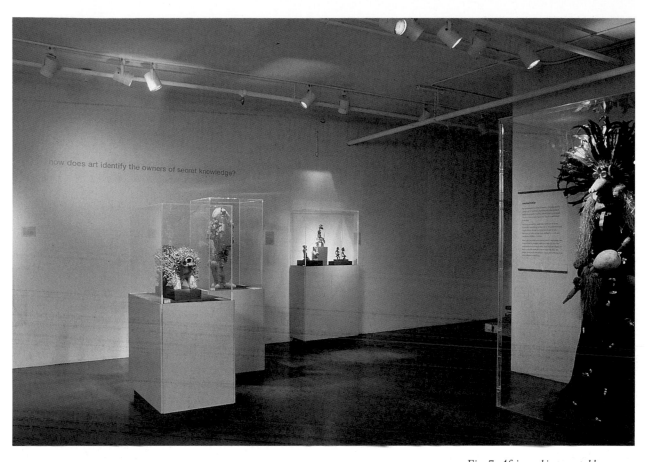

Fig. 7: African objects, notably a Banyang Obasinjom mask and costume, in the section of the "Secrecy" exhibition entitled "How does art identify the ownership of secret knowledge?"

MAYA LIN: I think there's a better title out there: "Exhibition-*ism*" doesn't do it for me. "Presentation" . . . it seems the more perfect word is "presentation"—how it's presented, not how it's exhibited.

BARBARA KIRSHENBLATT-GIMBLETT: I think that . . . most people would have a very benign response to "Exhibition" as a sort of neutral descriptive term. The moment you add "ism," right away you make it a nervous word. And I think it should be a nervous word. It is a nervous word.

MAYA LIN: In revealing knowledge, is it knowledge that you reveal only to yourself—or does someone teach you?

secrecy that the presence of a secret is apparent while its content is withheld—that in a way, the secret implies its own existence. Exhibitions similarly manifest revelation yet imply concealment. Behind museum walls, certainly in privacy and often with at least some degree of secrecy, anonymous museum staff make decisions, select and reject objects, assess quality, mold grant proposals, acquire and spend money, further careers, and edit information for public consumption. Exhibiting, then, is not simple revelation but rather an economy of partial disclosure. For every object and idea on display and in print, dozens of others have been eliminated along the way. Like a secret, an exhibition demands a dual process of revelation and concealment, absence and presence.

Key concerns of "Secrecy" included the relationships among knowledge, power, and art; the transmission of knowledge; the divisions and solidarities created by access to specialized knowledge; and the "knowability" of a culture and its art for members of another culture. Any museum visit raises many of the same questions, and involves many of the same processes. Indeed, museum visits might be compared to African initiation rites, as important occasions for the acquisition of secret knowledge: like an initiation rite, a museum visit involves the reception and interpretation of coded messages and the incremental accumulation of knowledge. Like a museum visit, an initiation rite often involves not so much acquiring new knowledge as learning to see the same knowledge in a new way—knowledge that cannot be transmitted through a book, or by rote, but only experientially, through isolation, contemplation, and the passage of time. At some level, both the initiation rite and the museum visit may teach the same, closely guarded secret—that there is no secret at all.

The ideas that inform "Exhibition-*ism*" are drawn from conversations with writers, filmmakers, anthropologists, philosophers, architects, ritual practitioners, museum curators and staff, and designers in the fields of lighting, graphics, and exhibitions themselves—all adherents, in one way or another, of the "ism" of exhibiting. Also included were professionals in the performing arts, a particular source of ideas for this installation. All of them work or have worked either with museums or in the theater, and all concern themselves with the purpose and power of visual display as an educational tool and a locus of personal and cultural enrichment. Many of their remarks are published in this book, in the hope that

32

"hearing the voices behind this show and its catalogue may be as interesting as seeing the choices and workings behind the curatorial veil of the museum and its exhibition. 'Exhibition-*ism*' shows that even when an authoritative presence is not apparent, not physically directing, not visibly displaying its hand, not audibly making commentary, it is still there through sleight-of-presence in the questions it asks, the voices it chooses to hear, and the choice of categories organizing its material. Fragments of conversation, like potsherds, can be lined up and ordered to tell a story as if the fragments themselves were begging the narrative. In the end, under the guise of many voices, there may be only one, the world of the museum/academy in conversation with itself about itself and its concerns. For the context of 'Exhibition-*ism*'—like all shows—is the show itself, even as it is offering us this peek behind the museum curtain and behind the curatorial veil."[2]

The Death of the Museum?

Just as African art is gaining a mainstream acceptance in the West, the role and future of the museum are becoming more ambiguous. New questions are being raised—not about form versus context or art versus artifact, but about the life of museums at large, and the shapes they will take in the century to come.

In 1984, the American Association of Museums published a handbook, *Museums for a New Century*, that combined an optimistic belief in the necessity of museums with a wary understanding of the challenge they face: "to retain their permanence and authority while embracing a larger public role and responding to new social responsibilities" (1984:18). As the twenty-first century approaches, serious doubts are being voiced as to the continued usefulness of the museum as we know it in a postmodern, postindustrial, information-centered age of computer data-bases, virtual reality, and, soon, 500 TV channels.

Are museums still relevant, or have they outlived their usefulness? Why has attendance at art museums dropped one percent each year for the past five years, even as the population has increased? Are museums broadening their audiences, and succeeding as alternative educational sites, or are the generations alive today among the last to take pleasure in isolating the visual from the other senses? For an increasingly mobile population, is the encounter that the museum offers, with one's own culture or those of other times and places, still provocative and satisfying? Can

JAMES CLIFFORD: It's . . . perennial. . . . Since I've been interested in museums, people have been talking about their death.

JOHN CONKLIN: Back to museums dying, because . . . people say exactly the same thing about opera, but the statistics [show that] . . . more people see opera than ever before . . . I think the numbers are the same for museums. There are all these new programs . . . to bring in people and make sure they see things. But at the same time there's this dissatisfaction. . . . The event you want these people to see doesn't happen.

ARTHUR DANTO: Are we sure the museum is going to survive? What do we need it for? It's not like a hospital . . . where there's always going to be sick people. . . . Why do you need a museum? . . . There's so many pressures on it in one sense, and at the same time . . . the hopes are so exaggerated, not because they think art is any longer going to automatically be the solution to any problem or that it's going to mean harmony or the bringing of beauty into lives.

the museum be more than a pallid reflection of television and film? What can make a museum experience transformative on a socially significant scale?

The museum as an institution developed in the mid-eighteenth century as an encyclopedic repository for the preservation of knowledge. In the world view it reflected, all of culture could be housed under one roof; Europeans could know the world through the museum's collections, and could construct a narrative of their own cultural heritage through its expositions. The placement of cultural artifacts within museum architecture both reflected and shaped collective memory (Yates 1966). African and other non-Western arts, if they were included at all, were usually relegated to the margins of the narrative—literally to the buildings' basements or attics. In the United States, this remained the case well into the 1970s.

Over the past two hundred years the museum has shifted from the encyclopedic to the specialized, and from the aristocrat's "curiosity cabinet" to a powerful public institution designed to diffuse knowledge and beauty to a broad public (AAM 1984:18). Just as dramatically, epistemological frameworks have changed so significantly in the last few decades that the notion of preserving knowledge in the positivist sense is no longer considered viable, and museums have been under pressure to move from an authoritative presentation of culture to an interrogative one. In addition, the political and financial requirements of serving diverse multicultural societies have put further pressures on museums to examine themselves, their messages, and their audiences. As a result, museums today are turning inward to question their pasts, their purposes, and their identities.[3]

Even the most apocalyptic visions of the museum's economic prospects and dwindling audiences still maintain the belief that these institutions have something to offer that is available nowhere else—mainly, a direct encounter with a work of art. Yet such a position is problematic: what kind of encounter is possible, through the Plexiglas and before the guards, with an object that has been torn from the cultural and temporal frameworks for which it was made? A vast ontological distance separates us from the lives and cosmologies of the great majority of the men and women who produced the objects we see in museums, even those from Europe or the United States itself.

Explicitly or implicitly, a belief in the direct encounter with artworks entails some notion of the object's authenticity or unusual nature. Yet museum exhibiting is

itself as artificial and conventionalized as any other kind of representation (see Yamaguchi 1991:67). A phrase Richard Schechner has used to describe performance applies equally to exhibitions: the "making and unmaking of realities" (1988:72). Nevertheless, museum exhibitions are a place where objects and ideas meet in a way found nowhere else. In the process of museological fission, ideas and objects coincide and collide, producing intellectual and emotional heat. The ongoing experiment of exhibition-making, of setting ideas and objects in motion, is the life of a museum like the Museum for African Art. It is the interaction of the ideas and objects, the special mix found in museums, that enlivens museum practice, and that offers it a road into the future.

1. Laura Scanlon, personal communication with the author, 1994.
2. Ibid.
3. A 1992 exhibition at the Parrish Art Museum in Southampton, New York, for example, "Past/Imperfect: A Museum Looks at Itself," curated by Donna De Salvo, explored the Parrish's own historical evolution, and the politics and social mores that have shaped and altered its sense of its mission over the years.

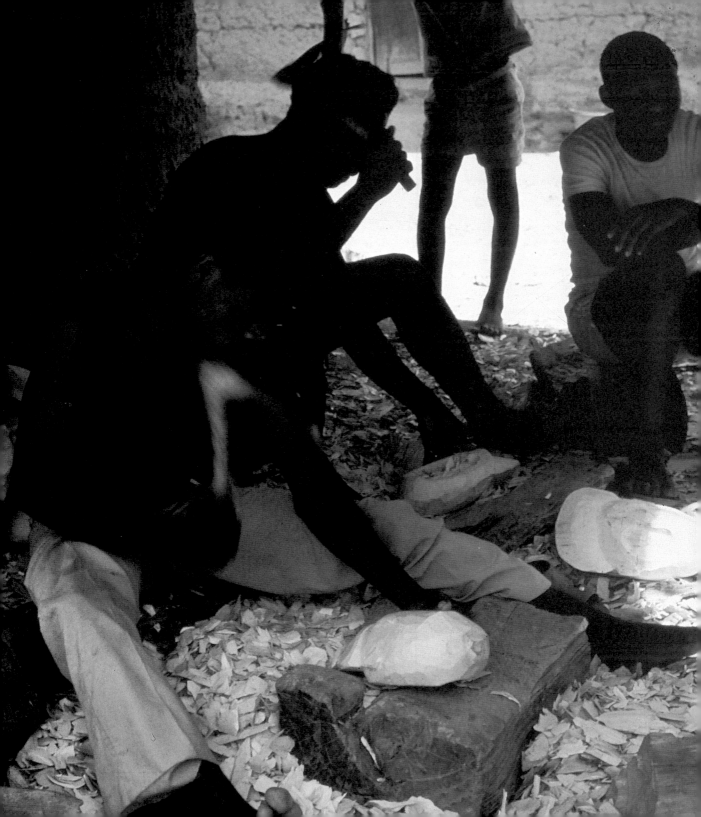

Does an Object Have a Life?

Mary Nooter Roberts

MUCH OF THE AFRICAN ART IN MUSEUMS TODAY derives from eras and places so removed and remote from the present that to retrace its history is nearly impossible.[1] Many objects arrived in the West as the trophies, souvenirs, and testimonies of colonial imperialism—the religious conversion and commercial exploitation of Africa from the fifteenth to the mid twentieth century. Documentation of these "entangled objects" (Thomas 1991) is often poor or completely lacking. Their exposition in the West reflects the historical attitudes of Westerners toward them and their makers— starting with turn-of-the-century constructions of Africans as "exotic others"— more than it does their meanings for their original creators, owners, and users (Vogel 1991:193).[2] Yet even if the ownership and display of foreign objects always ultimately reflects the exhibitors as much as or more than the producers, it is nevertheless important to consider how African peoples experience their relationships to objects and to the empirical world.

The ways in which artworks are collected, catalogued, conserved, and displayed express a culture's ideas of the ontology of objects, and of selves. A society's assumptions about the value and nature of objects are socially constructed, and vary over time. To discern them is a complex, multilayered task, even to a cultural insider, and all the more so when object and observer are foreign to each other, and when the observation takes place at great distances from the contexts and

ARTHUR DANTO: What is it to have a real encounter with the object? Most of these objects are radically dislocated: you're not going to encounter them in the way they were made, or in the way the people who made them encountered them—you can't even think of them that way. What's evolved over time is a certain standardized way of encountering the object.

Fig. 1 (opposite page): Baule artist producing masks for tourists, Boreakpokro, Côte d'Ivoire, 1984. One of the greatest challenges in museum exhibitions is the dislocation of works of art from their original makers. Do objects retain within them the act of their creation? Can that moment be re-created through the viewer's gaze?

37

the cosmologies that defined the objects, classified them, and informed their shape and meaning in the first place.

The Social Lives of Things[3]

Objects shape history, and history in turn transforms objects. African artworks have a history in Western museums, but they also have earlier careers and "life stories" in Africa. Those careers themselves encompassed changes of role. There is a tendency to think that an African object has a place of origin, an "original" context that is more "authentic" than any other, and that prior to the object's arrival in the West it was in its "true" setting. Yet in Africa, as elsewhere, context is always shifting, as are owners, users, viewers, and producers; and authenticity is as negotiable and relative a concept as value itself.[4]

First, African objects are often created by artists of different ethnic groups from their eventual users (fig.1). For example, Christopher Roy has described

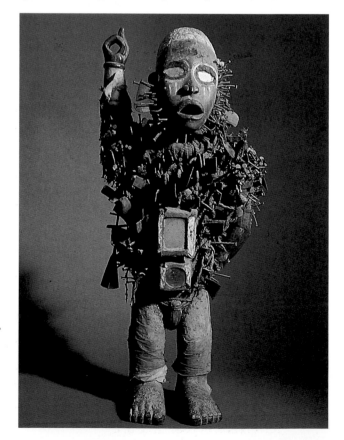

Fig. 2: N'kisi nkondi, Kongo, Zaire. Private collection. The surface of a Kongo n'kisi nail figure visibly records the multiple stages of the object's life. The cumulative addition of nails, blades, cloth, bundles, and other materials is a mnemonic device for the remembrance of each healing ceremony, trial, and oath-swearing to which the figure has been a witness during its lifetime.

important centers throughout Africa in which families and clans produce art of a certain style, which is then dispersed over large panethnic areas (1985:3). In earlier years too, in what is now Burkina Faso, Gabon, Cameroon, and southeastern Zaire, figures, masks, and royal emblems were often produced for export to neighboring groups, leading to homogeneous stylistic regions. African artists were also sometimes itinerant, moving from one area to the next as requests were made for their services. Furthermore, objects often have multiple makers, especially when they are accumulative, or when they are intended for consecration by a priest or specialist.

Beyond being dislocated from their original makers, objects may also pass through multiple exchanges, circulating as merchandise, dowries, gifts, inheritances, entreaties, payments, political symbols, and sumptuary articles. In the eighteenth and nineteenth centuries, for example, when the Luba kingdom was expanding, Luba royal emblems were in perpetual motion due to their ambassadorial role in alliances and their ability to articulate ideological precepts across cultural boundaries (see Reefe 1981, Nooter 1991). Such processes may involve redefinitions of the objects, even during the course of their lifetimes in Africa (see Bravmann 1972). As Arjun Appadurai states, "It is the things-in-motion that illuminate their human and social context" (1986:5).

Objects can also undergo radical transformations without movement or exchange. Igor Kopytoff discusses how function may change simply with age, and what happens when a thing reaches the end of its usefulness. He offers the example of a Suku house, which has a life expectancy of about ten years:

> The typical biography of a hut begins with its housing a couple or, in a polygynous household, a wife with her children. As the hut ages, it is successively turned into a guest house or a house for a widow, a teenagers' hangout, kitchen, and, finally, goat or chicken houses—until at last the termites win and the structure collapses. The physical state of the hut at each given age corresponds to a particular use. For a hut to be out of phase in its use makes a Suku uncomfortable, and it conveys a message. Thus, to house a visitor in a hut that should be a kitchen says something about the visitor's status; if there is no visitor's hut available in a compound, it says something about the compound–head's character—he must be lazy, inhospitable, or poor (1986:87).

MICHAEL BRENSON: I haven't been bothered as much by seeing a lot of [Asian] stone sculptures in museums with the same kind of lighting, let's say, that you would use here. But I do find that with the lighting, with the way an object is installed here, I'm not sure at a certain point what I'm looking at anymore. And I somehow always feel, rightly or wrongly—let's say with Indonesian or Indian sculpture—I still feel that even if it's ripped out of context I know what I'm looking at.

LABELLE PRUSSIN: On the coast of Ghana, women potters form their pots in two halves, shaping both the upper and lower halves separately, on the ground. These halves appear as earthen domes, literally, forms emerging from the ground below, on which they rest. In the creative process, one cannot separate the pot from the ground below it, so you are talking art in one case and environment in the other—evocative of an inherent appreciation for the landscape.

OBJECTS ARE BEST UNDERSTOOD, not by reconstructing their "original" use or context, but through the contingencies of their ongoing careers. Some objects— Kongo *nkisi*, Bamana *boli*, Fon *bocio*—change physically over their lifetimes through continued accumulative usage (Rubin 1974) (fig. 2). Freshly carved figures in a basket in a market in Ajara, in the Republic of Benin, for example, strike a spare contrast to the worked and layered surfaces of the same objects after their purchase, when the buyer applies organic and inorganic matter for therapeutic purposes, at which point they become *bocio* (figs. 3–5). Kongo *nkisi* figures too are in perpetual states of transformation. Beginning as bare wooden sculptures, over time they acquire innumerable offerings and consecrations by practitioners called *banganga* (MacGaffey and Harris 1993). Songye figures become so laden with power emblems that they are thought to have too much power to touch, and sticks must be used for handling them (Cornet 1978:287). Sometimes, as with *boli* altars, the exterior of an object, continually accumulating offerings, is a visible metaphor for the progressive internal accumulation of knowledge by the object's owners and users (McNaughton 1988:132).

For Arnold Rubin, accumulative art is "a distinctively African artistic convention" (1974:14). Besides reflecting phases in the making, production, and use of a work, accumulations uphold an aesthetic of "design redundancy" that serves to organize and concentrate energy (ibid.:10). They may range from "adjunctive" to "integumented," "reticulated," and "sheathed"—a language of progressive addition that marks time and reifies process.

Other objects may not change much physically but do undergo metamorphoses of their functions and meanings. As Eberhard Fischer explains, for example, Dan masks may hold diverse identities over their careers, changing in status and character during their owners' lifetimes: like an individual climbing the social ladder, a mask may ascend in rank, becoming a judge, say, or a peacemaker. In this sense, form alone cannot reveal a mask's life history. As one Dan person has explained, "Masks have mixed characters like human beings" (Fischer 1978:19).

The artistic practice of recycling is another demonstration of the ongoing lives of objects in Africa and of the creative spirit that informs relationships between people and objects there. Visitors to the continent today will see innovative, often witty and ironic uses of found objects and discarded materials, in an invention of new

forms that limns a territory between ritual and technology. In the Republic of Benin, artists incorporate aluminum car bumpers and copper piping into the ritual memorial sculptures known as *assanyin*, and use tin cans and burned-out lightbulbs in open-wick kerosene lamps (Roberts 1992a:54–63, 97).

Awareness of this tendency toward creative recuperation of objects and especially ideas enhances an understanding of African conceptions of permanence and perishability, product and process (ibid.:56). Different African cultures put different values on permanence. The Igbo people of Nigeria, for example, according to Chinua Achebe, do not particularly like to collect or preserve the objects associated with *mbari* houses. As James Clifford paraphrases,

> The purposeful neglect of the painstakingly and devoutly accomplished *mbari* houses with all the art objects in them as soon as the primary mandate of their creation has been served, provides a significant insight into the Igbo aesthetic value as process rather than product. Process is motion while product is rest. When the product is preserved or venerated, the impulse to repeat the process is compromised. Therefore, the Igbo choose to eliminate the product and retain the process so that every occasion and every generation will receive its own impulse and experience of creation (1985:241).

Herbert M. Cole documents this aesthetic of process in *mbari* architectural complexes, with their rich and perpetually changing iconographic programs (1982). As Cole points out, the goal in *mbari* construction is not to perpetuate traditional motifs, but constantly to update existing themes in a way that incorporates the surrounding world within the building.

In contrast to Igbo attitudes that privilege process over product in the context of *mbari*-related arts, the Dan preserve and care for masks even after they no longer serve their purpose. Fischer and Himmelheber writes,

> The masquerades are the spirits manifest. . . . The mask does not merely represent that spirit, it is that spirit. The spirit operates in the face mask whether it is worn or not. Consequently, old face masks which are no longer worn are still precious. Their owners often address requests for extraterrestial help to them. To discard an old mask would be unthinkable.

LABELLE PRUSSIN: African earthen granaries, of which the huge, swelling, pregnant pots built by the Djerma on the banks of the Upper Niger are only one magnificent example of architectural pottery, are not considered viable by their users until the sacrifices and libations which imbue them with life have been performed. The container may be a perfectly sound container in the structural as well as the sculptural sense, but its users do not perceive it as such until the relevant rituals have been carried out. And so it is the human act of invocation that turns the artifact into art.

IVAN KARP: Exhibit the problem, don't exhibit the solution.

41

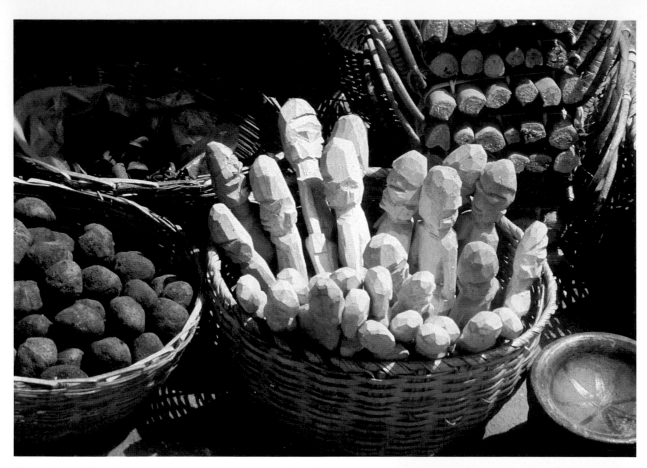

Fig. 3: Basket of Fon figures in a market display, Ajara, Republic of Benin, 1994. Such moments of consumerism are often an early stage in the life of a bocio figure, and are characterized by the multiplicity of objects on display—one work indistinguishable from another.

Fig. 4: Fon bocio figure in situ, Gbakpo, Republic of Benin, 1994. Following purchase in the market, this figure was half buried in the ground at the foundation of its owner's house, after receiving applications of signifying substances to its surface. As an object is collected, it is taken out of the commodity sphere and thus singularized.

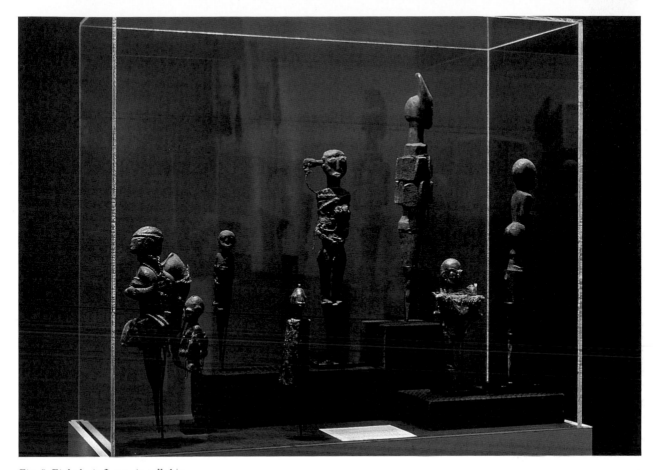

Fig. 5: Eight bocio figures installed in the "Secrecy" exhibition, Museum for African Art, 1993. Bocio figures acquired by foreigners may find their way into museums, where they go on to have another career as works of art or as artifacts. The display case shown here contains eight bocio included in the "Secrecy" exhibition to illustrate how certain artworks serve the therapeutic purpose of holding the private secrets and problems of their owners.

MICHAEL BRENSON: Maybe stone automatically has such an implication of centuries, of knowledge built into it.

BARBARA KIRSHENBLATT-GIMBLETT: Is it possible ever to talk about this material without always invoking colonial encounter? . . . I don't want to overwhelm this material and the viewing of it with a kind of relentless colonial framework.

Old or damaged masks get copied by a distinguished sculptor and the spirit is entreated to accept the new face. A mask must be cared for with respect until it disintegrates (1984:8).

THERE IS NO UNIFORM AFRICAN PHILOSOPHY concerning the nature of objects, but while all objects can and do have life histories, few are considered to be "alive" in an autonomous sense. People in most African societies, such as the Nteso of Kenya, believe that objects can have effects, but only through human agency.[5] In other words, objects do not have life-force innately, but only insofar as they are invoked through devotion. Thus many objects and shrines—Yoruba *ibeji* twin figures, Baule spirit-spouse sculptures, Akan *akua-ba* fertility dolls—must be "fed": offerings of food must be made to them (fig. 6). They may also be fastidiously and lovingly caressed, washed, and adorned. Other objects must be activated with each use: blades driven into the surface of a Kongo *nkisi* awaken it from slumber. A Luba *kashekesheke* divining instrument is rubbed with a special aromatic leaf to arouse the spirit for divination. An Akan blackened stool receives sacrifices to harness its attention and its mystical powers. Finally, many types of charged objects in Africa require mediators: possession states for Luba royal emblems, hallucinogens for Fang reliquary guardian figures, medicines for Efe Gelede Great Mother masks. The requirements of mediation underscore the powerful life force that can be mobilized and harnessed by such objects and shrines, but only through the interventions and interactions of their makers, owners, and users.

Creating Loci of Power

Many researchers have used the word "shrine" when discussing objects of capacity and power, sites or loci of supernatural agency.[6] The construction of shrines and objects of power is based on the manipulation of the taxonomies and categories that cultures invent to order the natural and supernatural worlds. Michelle Gilbert discusses the assemblage of elements in a shrine in Ghana as a deliberate and dangerous crossing of socially circumscribed boundaries: "a mingling of contrasting elements . . . said to contain power in a new and greater form" (1989:65). Similarly, a Kongo *nkisi* mixes ordinarily separate, mutually exclusive categories in ways that inspire terror, astonishment, and power (MacGaffey and Harris 1993).

44

The complex fabrication of shrines and medicinal objects can be understood through the organizational principle of synecdoche, or part-for-whole reduction. A Tabwa medicinal bundle is composed of parts and fragments that have been reduced or compressed from certain wholes—the hair of twins, for example, or the nails of an ancestor, the scales of a pangolin, or the burnt bones of a thief (Roberts 1992b). Such a bundle, like a Bamana *boli*, condenses and fuses the universe within the object's

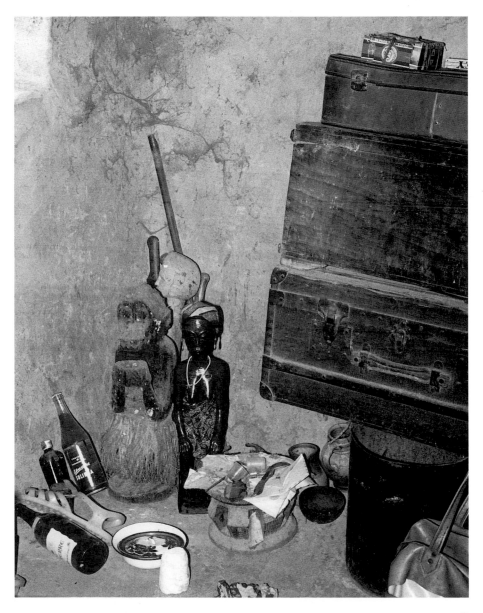

Fig. 6: Baule spirit spouse figure in situ, Akwe area, Côte d'Ivoire, 1978. Many of the African sculptures that in the West we would designate as art were originally used in shrine contexts, where their owners gave them gifts and blessings as signs of devotional love and respect. Although the figure is not considered to be "alive," it is thought to be a locus for a spiritual being, who is activated by the offerings of food and drink.

single, bounded, empirical space. This is synecdoche at work: the condensation and channeling of energies and capacities within a unique symbol. The manipulation and reclassification of the bundle's discrete components metaphorically reflect the maker's ability to control cosmological forces on a grander, sometimes supernatural scale.

The African construction of a shrine or of a medicinal bundle mirrors certain aspects of the Western museum practice of collection and classification, or at least provides a metaphor for the process. As Danielle Jonckers writes of Manyan altars, "veritable microcosms, the altars of the Manyan are made of an amalgam of different fragments taken from the vegetal, animal, and human worlds. Numerous criteria determine the gathering of these elements if they are to be suitable for the making of the *yapèrè*: order and place of collection, color, type, etc. The core is made of rare objects" (Jonckers 1993:84; author's translation). Western art-museum exhibitions of non-Western art are also microcosms, amalgamations of fragments borrowed from diverse, often incongruous or even conflicting realms. After its removal from one culture and its assimilation into another, the object often comes to stand for the entire culture and cosmology whence it originated: "the object is a part that stands in contiguous relation to an absent whole that may or may not be recreated" (Kirshenblatt-Gimblett 1991:388). Clifford, to illustrate Susan Stewart's discussion of decontextualization, offers the example of a Bambara (Bamana) mask that is first cut out of its cultural and historical context, then transplanted to a Western museum where it is displayed in a new setting to represent all of Bamana culture (1985:239; cf. Steiner 1994:93).

Just as the minute components of a medicinal bundle metaphorically allude to the owner's power on a grand scale, museum displays often express larger ideological positions: to take possession of another culture's artistic heritage is evidence of the appropriating culture's power—evidence of cultural imperialism.

The Ethnographic Fragment

Exhibition curators appropriate objects from otherwise irretrievable worlds and reconstitute them as art, artifact, craft, or souvenir. What turns the ethnographic fragment into a work of art is a process of commodification, singularization, and reclassification. Any object removed from its originary context has been taken out of

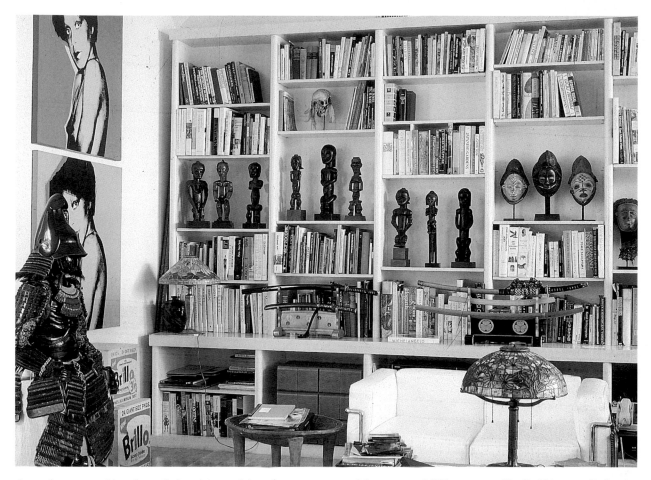

time; the removal is a form "of excision, of detachment, an art of the excerpt." Who decides what is worth saving? Who decides what constitutes the object's context? "This I see as an essentially surgical issue. Shall we exhibit the cup with the saucer, the tea, the cream and sugar, the spoon, the napkin and placemat, the table, the chair, the rug? Where do we stop? Where do we make the cut?" (Kirshenblatt-Gimblett 1991:388).

Ethnographic objects are fragments because they are products of detachment—not only from a physical place of origin but from deep cultural ties. The objects that we call African art are all fragments, segmented and dissociated. They are the portable portions of faraway cultures. Following their introduction into the new culture, they may navigate "from curio to specimen to art, though not necessarily in that order" (ibid.:392).

Fig. 7: African art displayed in the home of the artist and art collector Arman, New York, 1994. This interior shows African art alongside various sorts of contemporary art, found objects, and ordinary household items. The placement of African objects in Western homes complicates the usual distinction between "real" and "fake": can an African object that was used in its original context—and is therefore "real"—be called authentic when it appears on a New York bedroom wall? Does the context of the work affect its authenticity?

47

Once out of Africa, objects may enter a circuit of ownership and marketplace exchange that includes museums, collectors' homes, galleries, auction houses, flea markets, artists' studios, corporations, and banks. When an object enters the commodity sphere, it often becomes more and more valuable, exchangeable for more and more other objects. As it is collected, it is singularized and sacralized. This politics of value is often a politics of knowledge, as Simmel writes in *The Philosophy of Money*: "We call those objects valuable that resist our desire to possess them" (1978:670; cf. Smith 1988). The same principle underlies the secret: the more unavailable a certain piece of information is, the more powerful and desirable it becomes.

Though a museum's acquisition of an object is generally taken as a proof of the object's value, at the same time, paradoxically, it signifies that the object has been decommodified, taken out of the market, and out of time. Transplanted to the synchronic, simultaneous temporal frame of the collection, the object is reclassified. Any specific collection effectively destroys an object's earlier contexts at the same time that it creates a new one. The new context stands in a "metaphorical, rather than a contiguous, relation to the world of everyday life. . . . The collection replaces history with classification . . . thereby making temporality a spatial and material phenomenon" (Stewart 1984:152–153).

To say that collections and museums transform the diachronic narrative of history into a sychronic one is another way of saying that they turn time into space: "The relationships of objects in time are transposed into a spatial context, and the regrouping is imprinted in the memory of visitors. This transformative capacity of museums, their ability to function as machines for turning time into space, enables them to be used as an apparatus of social memory" (Yamaguchi 1991:61). In the museum, objects become freeze-dried images of the cultures from which they came. An object's accession by a museum, however, is not the end of the many reclassifications it undergoes. Even within the museum setting, an object may move around—from storage to the conservation lab, to a study collection, to the display case, to the shop. And it may be lent to other museums for temporary exhibitions, which reclassify it again. The more phases and cycles in an object's life history, the more "fame" it acquires: "The biography of things in complex societies reveals a similar pattern. In the homogenized world of commodities, an eventful biography of

a thing becomes the story of the various singularizations of it, of classifications and reclassifications in an uncertain world of categories whose importance shifts with every minor change in context" (Kopytoff 1986:90).

The acquisition of an African object by a Western museum is not necessarily the last stage in its career. Its image may be reappropriated by an African country, for example, to serve as a national symbol of collective memory, and to appear in new contexts—as an advertisement on building facades, on currency and stamps (Vogel 1991:230), even on airline travel-sickness bags. These new contexts indicate the recycling of old forms for new purposes and contemporary needs.

Authenticity: "Recovering the Shock of the Original"

An understanding of the cycle of decontextualization, reclassification, and removal from time necessarily raises issues of authenticity. Most value assessments of African artworks are based on the myth of the "authentic," a notion based on the distinction Africanist art historians and connoisseurs draw between objects that have been made and used by Africans and those made for the trade. Yet there is a contradiction in this dichotomy. As Fred Wilson asks, "How 'real' is a so-called 'real' mask or shrine figure when not in spiritual/ceremonial use? When it's on a bedroom wall or in a Plexiglas display case?" (Flam and Shapiro 1994:93) (fig. 7). To what extent, in other words, does context alter a work's "realness"? Is "realness" inherent in the work?[7] And how does the making and breaking of classifications affect an object's "authenticity," or the viewer's judgment of its authenticity?

The question of authenticity in the museum context may be framed by looking at individual objects in terms of activation and desacralization.[8] When a Kongo *nkisi* loses the medicine pack that once activated its power, or when a reliquary guardian figure is detached from its relics, is it "deactivated?" Does separation of an activating agent from its sculpted container neutralize container, activating agent, or both? What is the link between the inside and the outside, the container and the contained? Does the aesthetic perfection of the container set the medicine in motion, or is the container an arbitrary receptacle for the medicine?[9]

On the other side, if artworks are *not* rendered defunct by removal to a museum setting, or by the separation of their parts, what are the ethical implications of putting them on display? If they are or have been the objects of an African family's

ARTHUR DANTO: When I gave the talk about this Dominican child—there's this guy, what's his name—at any rate, he said, "No, now when black children go to a museum they want to see black things." I don't know if that's true or not, I just don't know—whether or not that's a piece of ideology that's been superimposed on the experience, whether things like that don't mean very much. I thought it was interesting he said that, and believes that. That meant any museum he's going to have anything to do with is going to be like that. Like a mirror house where you go in and encounter yourself—that might not be a bad thing.

BARBARA KIRSHENBLATT-GIMBLETT: The secrecy theme finally has to do [more] with our interest in this material than the material itself.

Fig. 9 (below): Reconstruction of an early-twentieth-century altar to the Yoruba thunder god Shango, based on an archival photograph and using objects that would have adorned such altars, as installed in "Face of the Gods," Museum for African Art, New York, 1993.

Fig. 8: Detail of fig. 10, showing the altar after visitors have left offerings of money, flowers, and other articles. In "Face of the Gods," altars that re-created earlier altars elsewhere, and that were made specifically for this exhibition, were treated by their public as if they were sanctified—as indeed they had been. The interactions of visitors with the works on display added a new spiritual dimension to the museum experience of African art.

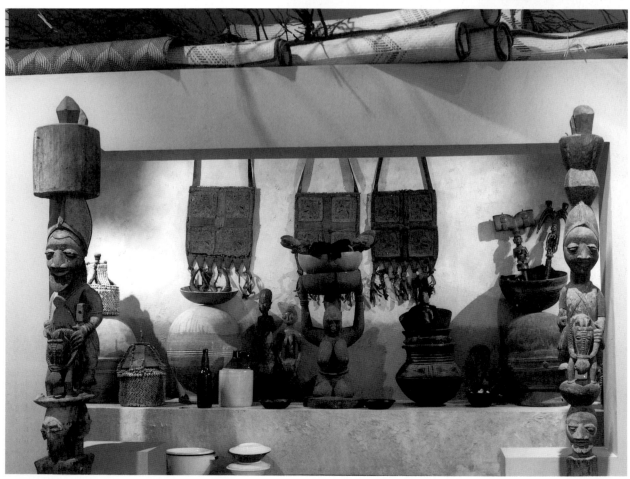

Fig. 10:
Afro-Brazilian altar to the Yoruba creator god Oju Oxala, also known as Obatala, as installed in "Face of the Gods," Museum for African Art, New York, 1993. Based on an altar made by Mai Jocelinha in Salvador, Bahia, in 1982, this version was built by Eneida Assunçao Sanches.

IVAN KARP: It's very difficult to engage audiences in a dialogue. The most successful example I know is "Field to Factory," at the American History Museum. This is an exhibit about black migration from the South to the North, and at one point, in order to go from one room to another, you have to go through a door marked "Colored" or a door marked "White." You have to. And people back up, they pause, they hesitate. They don't know whether to make a gesture or obey the rule—they have to confront "Why am I doing this?" It's not an equal dialogue [between audience and curators], because clearly the designer holds a certain element of power here . . . but it's a dialogue, as opposed to a lecture, or a slide show.

worship, does a museum have a right to own them? A Bembe figure shown in the "Secrecy" exhibition is said to have contained the breath of an ancestor before the sculpture was "uncorked"; does the power of that breath still inhabit the sculpture? Do *bocio* figures still hold the private secrets of their owners, and do the amulets on a hunter's shirt still store the man's personal knowledge? What of objects that are partial—the Luba figure that has lost its calabash, the Fang reliquary whose secret compartments are empty? Some figures, impenetrable without breakage, have been x-rayed by the museums and individuals that own them; whether or not the x-ray reveals the objects' contents, doesn't it transgress their secrecy? Do these works still hold power, or are they activated only through the complex African rituals that surround them? Can museums re-create those rituals? Should they even try?

In Africa, the activation of a work can be effected in a variety of ways. Consecration through sacrifice and the presentation of offerings is one method, in which an obvious, physical addition is made to the work, whether temporarily or permanently. But there are also more ephemeral means that include kinesis and exegesis, for example dance, song, trance, narrative, and movement. Sometimes it is the combination of all of these, "a synaesthetic totality, inseparable from associated dimensions of sound and movement" (Rubin 1974:6), that constitutes the "life" of the work.

The Museum's exhibition "Face of the Gods: Art and Altars of Africa and the African Americas" (1993), curated by Robert Farris Thompson and assisted by exhibition consultant Daniel Dawson, demonstrated how objects can change and come alive through the museum setting. The show's twenty or so altars, from diverse centers of Afro-Atlantic worship, fell into three different types: altars originally made for use, transported from their sites for the duration of the exhibition, to be returned at its end; altars commissioned by the Museum from artist practitioners of the religions in question, who worked on site to create altars specifically for the exhibition; and, finally, re-creations of both historical and contemporary but untransportable altars designed and fabricated, from photographs, by the museum's exhibition team (figs. 8–10).

The Museum's staff was well aware of the problematic aspects of re-creating altars for public exhibition, and of juxtaposing altars from ordinarily discrete religions. Some felt these decisions were justified insofar as the essence of the

religions represented, such as Cuban Santería and Brazilian Candomblé, is their creolization—their ability to fuse multiple spiritual strains and to accommodate the present in a perpetually dynamic mode. (Indeed many of these religions surround us in our everyday lives in New York, on street corners and in neighborhood *botanicas*.) Yet the exhibition certainly did raise questions about authenticity, about the aesthetic and ethical implications of activation and desacralization, and about the presentation of living religious works in a museum context. "Face of the Gods" fueled debates amongst staff members, docents, and visiting students and scholars about the consecration of religious works for museum presentation. Should the altars be presented strictly as works of art, and viewed in terms of color, pattern, form, and iconography? Is their activation part of the aesthetic whole? Does the Museum tread dangerous ground in allowing the display of consecrated works? Might such display confuse religion with art? What, then, of European medieval relics and devotional imagery in conventional art museums across the country?

In the end, the decision was left to the builders of the altars, and most of these artists considered an altar with no blessings to be a lie. As a result, some of the altars made for the exhibition were brought "alive" by their makers. A number of them contained organic matter; one altar had rum poured regularly on it as libation. But the altars were "alive" not only through such invocations and incorporations of organic substances, but because the audience responded to them as living entities. Visitors left money every day—both on the altars that were re-creations by museum staff as well as "originals" and new altars built by artists of the faith (fig. 8). By the end of every week in the show's run, the ceramic dishes and cloth-covered platforms of many altars were literally transformed by the offerings made to them.[10] In addition, some visitors made gestures of respect, offering prayers and song, or even kneeling or lying prostate. These offerings were not merely visible signs of engagement, but also acts of innovation—contributions to the creative process.

The notion that beholders of an artwork add to the display through their own innovation is an aesthetic principle in many African cultures, and also in Japanese aesthetics:

> It is understood that Japanese gods do not appreciate true things; they do not accept things that are not fabricated by means of a device (*shuko*). One must add something to that which already exists in order to present it to

CAROL DUNCAN: A few years ago . . . I went for the first time to the exhibits . . . of Southern migrations in the American History Museum. And I have never been more moved in any exhibition anywhere than by that exhibition. . . . They had an actual double door from a train station, that was [marked] "Whites Only" and "Colored Only," and you actually had to walk through one or the other of those doors. And then . . . there was a cutaway of an actual train from the 'teens or '20s, and in that train was a mannequin of a single young woman asleep. . . . It got very, very quiet. There was just one figure, and I suddenly got scared—I felt frightened. I realized that, God, I just did this. . . . [the exhibit] made me live an experience of traveling, of being alone, of there not being any noise. . . . I have never had such a real experience before in a museum.

MAYA LIN: Counterintuition is really interesting. . . . sometimes it's really interesting to take something, to look at it backwards. . . . Our faces aren't symmetrical, and if we reverse our faces we look really different. There is something . . . that will always completely take me aback. Things that look so similar can be so different just by reverse.

gods or to show it in public. The art of flower arrangement (*ikebana*) originated in the tradition of *furyu*, and was meant to astonish gods with its ingenuity. It is the adding of something different—an act of eccentricity (Yamaguchi 1991:65).

"To astonish the gods with ingenuity" is a driving force behind many African art forms, particularly masquerade festivals. The Gelede masquerade performances of Yoruba people in the Republic of Benin, for example, are competitions among age groups in which each group strives to outdo its rivals, leading to extraordinary feats of ingenuity on the part of mask makers. Some refer to such innovation as *ara*, the notion that something should never be done the same way twice. *Ara* links existence itself with the creative act (Roberts forthcoming (a))

The altars in "Face of the Gods" silently invited the participation of viewers in the creative process. As visitors left offerings on the altars, they also took something with them in their memories of the enactment. In this way, the exhibition became a dialogue between objects and visitors, and by the end of the exhibition's New York run the altars were different entities from what they had been upon installation; they had accumulated the blessings, offerings, and devotions of their visitors. "Face of the Gods" effectively demonstrated that authenticity is not a physical state or a material essence. Rather, "authenticity is when the idea is pure."[11]

1. This question was raised by exhibition designer Maureen Healy at the Museum for African Art's symposium "Africa by Design: Designing a Museum for the Twenty-First Century," in May 1992.

2. For more sources addressing issues of African representation and the construction of the "other," see Vogel 1989 and 1991, Clifford 1988, Price 1989, Schildkrout and Keim 1990, Karp and Lavine 1991, and Mack 1991, among others.

3. This title is drawn from Arjun Appadurai's *The Social Life of Things* (1986).

4. The contingency and negotiability of objects' values are discussed by Barbara Smith: "The specific 'existence' of an object or event, its integrity, coherence, and boundaries, the category of entities to which it 'belongs,' and its specific 'features,' 'qualities,' or 'properties' are all the variable products of the subject's engagement with his or her environment under a particular set of conditions. . . . Each experience of an entity frames it in a different role and constitutes it as a different configuration, with different 'properties' foregrounded or repressed" (1988:31–32).

5. Karp, personal communication with the author.

6. Albert de Surgy's *Fétiches II: Puissance des objects, charmes des mots*, which is devoted to the subject of the "fetish" as an object category, examines the shortcomings of the term "shrine," and of others such as "power object" (1993). As Danielle Jonckers points out, there are simply no French equivalents for the words

Africans use to designate objects. The closest word to "thing" in Minyanka, for example, implies notions so important that one avoids naming them or referring to them at all (in ibid.:66). "Manyan shrines cannot be defined in Western terms, and cannot be considered as objects in the Western sense. At the same time spirit and matter, they incorporate religious entities" (ibid.:70; author's translation).

7. The idea that works contain within them the act of their creation has been discussed by many art historians and critics. In the action painting of the 1940s and '50s, that creative moment was intended to be reenacted in the viewer's gaze, making the work a performative space of its own (Müller, personal communication with the author, 1994).

The subhead to this section, "Recovering the Shock of the Original," is taken from an interview with Peter Sellars.

8. David Freedberg presents differing positions on the issue of sacralization and consecration. Objects are activated by consecration, but only when they already have a signifying function of their own; in other words, consecration realizes the potentiality of an object (1989:98).

9. Wyatt MacGaffey explains the activation of an nkisi in the following way: "In wooden figures, medicines are contained in any of several locations and sealed in the top of the head, on the back, or between the legs. The most common place is the belly, partly because mooyo, 'belly,' also means 'life.' As Nsemi Isaki tells us, 'An n'kisi that lacks medicines can accomplish nothing; they are its being, its hands, its feet, its eyes. Medicines are all these, so an n'kisi that lacks medicines is dead and has no life'" (1993:43).

10. The money deposited on the altars was collected regularly and was used at the end of the show's New York run to renew some of the materials used in the altars' fabrication, such as cloth, dried flowers, and feathers.

11. Daniel Dawson, personal communication with the author, 1994.

Outside Inside: The Space of Performance

Mary Nooter Roberts

WHAT KIND OF SPACE IS CONDUCIVE TO RECOVERING the shock of the original? How do objects and the spaces that contain them activate one another? How does the articulation of space define inside and outside, and identify the viewing subject? How does it direct or deflect the gaze?

Shaping Spaces of Containment

When an object is excised from its original context and removed to a foreign museum, it can rarely be reunited with its previous "whole," its context, locus, or container. Its new space will have no intrinsic connection to it, or to its makers. Some museums create metonymic displays, presenting objects as fragments of the cultures from which they came, and using their partiality to enhance their aura of realness. Others try to reconstruct aspects of the objects' previous contexts, in a process of mimesis[1]—though no matter how closely a space approximates an object's previous setting, it remains a simulation of reality, an artifice. "An 'innocent' reunification between the fragment and the whole is no longer possible; the intervention of artifice is a necessity" (Colomina 1992:110; see also Baudrillard 1983).

Architecture was once considered an authoritative and neutral container. Yet ideas of indeterminacy and illusion now infuse architectural theory, and buildings are

Fig. 1 (opposite page) : A recreation of an African-American yard show in the style of Black-Austin, Texas for the Museum for African Art exhibition, "Face of the Gods," curated by Robert Farris Thompson. The installation of an outdoor yard show within museum walls illustrates the ambiguous role of the museum as a container for visual ideas that overflow the boundaries of architectural space.

AYUKO BABU: One of the most fantastic things about Burkina Faso, in Ouagadougou, is that here's a country that is supposedly poor, but [it has] all these fantastic buildings. You have buildings with lizards on the front . . . and incredible, beautiful buildings that do invite you in. I think that needs to be transferred to the outside facade here [at the Museum for African Art].

MAYA LIN: You can begin to bring people in, literally, by painting the sidewalk, graffiti that is sort of unexpected on the floors, in the symbols that come right into the lobby. . . .

CAROL DUNCAN: In a way, you're saying so much by making the contents spill out. It's a different idea of making the inside spill out to the outside and leave its mark on the outside. I think that is conceptually more exciting than trying to figure out how to transpose another culture into the architecture of a New York building

understood as representations: "The perception of space is not what space is but one of its representations; in this sense built space has no more authority than drawings, photographs, or descriptions" (Colomina 1992:75). Perceptions of space, like attitudes to objects and approaches to exhibiting, are cultural constructions that reflect historical biases. And buildings, like objects, have ongoing, changing histories and identities.

Since it opened, in 1984, the Museum for African Art has occupied two different sites—a pair of brownstones uptown on East 68th Street (fig. 1), and a nineteenth-century cast-iron-and-brick building downtown on Broadway, in SoHo, renovated by architect/sculptor Maya Lin, designer of the Vietnam Veterans Memorial in Washington, D.C. Furthermore, the Museum's exhibitions have traveled to more than fifty institutions in the U.S. and abroad. Each of these changes of space and location has affected the viewer's experience of the art shown; each has demonstrated, in practice as well as theory, that exhibitions look and feel different in different settings. For museum space itself articulates meanings and messages, conveying a dialogue of inside/outside, subject/object, and encounter/nonencounter.

African Exhibition Spaces

In Africa as elsewhere, approaches to architecture and exhibition reflect culturally specific attitudes to space. Besides mounting commercial and noncommercial art displays in markets, mosques, and palace and national museums, people construct tombs, shrines, and altars in indoor and outdoor spaces that include village compounds, yards, house exteriors, sacred groves, and crossroads. Most "exhibitions" in Africa are staged in the spaces of everyday existence, of which they are often a part.[2] And when they are divided from daily life, the terms that separate them from it, though powerful, are often quite minimal. African notions of the "museum" are astonishingly diverse, but generally speaking they are often action-oriented, self-referential, and more conceptual than physical, approaching the idea of a garden without walls, a painting without a frame (Walker and Blake 1991:120). Through abstract, often barely tangible signifiers, the spaces of exhibition are localized not in a hermetically sealed, closed-off, walled-in institutional edifice but in the imagination—in a conceptual space.

In Dogon funeral rites, masqueraders dance at nighttime on rooftops, wielding flaming torches whose light creates an ephemeral, kinesthetic perimeter for the ritual precinct. Tabwa chiefs also use firelight to create a space of performance: young descendants of the chief gather in the evenings within the circle of light thrown by the fire to hear stories told by the elders, and thus to participate in the transmission of their cultural heritage. The circle of light restates the form of the chief's emblematic genealogical "belt," worn to encircle "not only his own life, but those of all his subjects" (Roberts 1980:488).

Space is sometimes delineated by sound rather than by material barriers. In many parts of Africa, auditory masks—masks with an acoustic but no visual dimension—are used to ward noninitiates away from sacred precincts (Lifschitz 1988 and Peek, 1994). Dogon specialists use the eerie, whirring, otherworldly sound of bullroarers to mark moments of transition, for example to announce that the Great Mother mask will leave its resting cave to offer benediction to the deceased. Staging areas are created through other sensory perceptions as well, including smell—a potent delineator of space. The smell of certain foods being cooked, and of beer being brewed, often indicates the preparation of ceremonial space for funeral and initiation rites.

Physical boundaries may be as minimal as a simple string or veil to mark a place of passage or transition in the stages of initiation, or as the floating walls of decorated cloth draped behind the royal displays of Cameroonian kings. Mosques in the Sahel can range from the most architectonic of cement structures to a simple stone outline in the sand (fig. 2). The "Boundaries" section of *Secrecy* discusses ephemeral boundary markers in many African contexts of performance and ritual (see pp. 141–203).

In Africa, artworks are deployed on "stages" that overflow the definitions and parameters of space as articulated in Western museums. Fang reliquary figures were kept in shrine houses from which they were sometimes taken and danced above the raffia bark screens at the edge of the forest (Fernandez 1992:31). Kuba peoples delineate sacred spaces within the forest for the fabrication and rehearsal of masks during initiation proceedings. The boundaries are marked by raffia barriers suspended along the footpaths leading to the forest camps; as the novices return to the village to perform, these boundaries are enlarged through the use of portable

LABELLE PRUSSIN: The built environment in Africa, i.e. the environmental arts, is composed of an amalgam of what the Western world categorizes into discrete art forms. Earthen buildings constitute a continuum from earth to finished form. They are often merely a conceptual extension of a piece of pottery; furthermore, pottery itself is often integrated into the architectural form. Potters, woodworkers, and blacksmiths who may normally create other kinds of art forms are equally as essential as the masons in putting a building together. For example . . . the poles which support the inner structure of a Tuareg tent in northern Mali, carved by the blacksmiths, become the ritual posts which support or surround a marriage bed and ultimately tomb markers in a cemetery. And so art form and architectural form are integral with each other.

markers placed on the initiation paraphernalia itself, including large forest leaves fastened to the masqueraders' skirts and to a conspicuous placard carried at the front of the procession (Binkley 1990:160). Thus the boundary lines of the ritual precinct shift with the performance itself. Many other art forms are displayed in spaces that are contiguous, mobile, temporary, and journeylike, including royal processions that can extend throughout the space of a town or village over days and even months.

Storage spaces can be as variable as display spaces. Dogon, for example, use the cave-ridden escarpment above their villages in Mali as a veritable museum, a repository for reliquaries, dangerous or polluted materials, and certain sacred masks. Yoruba store the *Iyanla* Great Mother masks and sacred medicines in secret shrines in rock shelters (Drewal 1977:564). Baule keep "old things of value" in storerooms and funerary display items in suitcases.[3] Luba diviners keep their instruments in large baskets (Nooter 1991:205), as do Lega initiates (Biebuyck 1973:87). Healers in many different African societies store their medicines in tortoise carapaces, insect casings, and antelope horns. The range of storage facilities, and their differing degrees of permanence and perishability, reflect notions about space, and the kinds of space required to contain the energy of the works inside.

Architecture and the Environment

African architecture is often inseparable from its environment, and its structures—the domestic and communal shrines within which objects may be stored and displayed, for example—are almost always perishable and renewable. Often earthen, built from wattle and daub, they are regularly rebuilt, allowing for the incorporation of new elements and designs (Denyer 1982). Links between pottery and architecture, even a continuum from a piece of pottery—an extension of the earth itself—to an entire earthen building, can be clearly seen in the architecture of the Sahel (fig. 3).

Besides identifying built space with the environment, people use topographical features such as mountains, lakes, stones, and forests to orient themselves in space, and to develop a sense of historical depth in relation to the landscape (figs. 4–5). Topography can invoke memories of events and historical moments associated with particular places, events often recorded in oral literature. A landmark such as a grave, the site of a royal court, or the scene of an episode from oral history may be identified by a tree, for example. Trees endure while walls fall

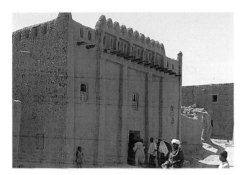

Fig. 2 (above, left):
Traveler's mosque,
Dakar, Senegal, 1994.
Sacred space in Africa
may be designated through
the most minimal of
physical boundaries.
Mosques in the Sahel can
range from architectonic
cement structures to
simple stone outlines in the
sand. A mosque in Dakar,
overlooking the Atlantic
Ocean, serves travelers
who need to stop at the
side of the road to pray at
the five ordained hours of
the day.

Fig. 3 (below, left):
Earthen dwelling in
Djenne, Mali. Earthen
architecture in the
Western Sudan reflects a
conceptual link to pottery.
In Mali, vernacular
architecture, including
elaborate mosques and
university buildings, need
not be permanent; it can
be perishable and
renewable—perfectly
blended with its
environment in its
material, color, and form.

Fig. 4 (below): Circle of
stone megaliths, east of
Nioro du Rip, Senegal,
1994. Stone megaliths in
southern Senegal are
arranged in rings and
concentric circles to mark
sacred space and to honor
those who died at the site
in some past event. Little
is known about the history
of these imposing
monuments, but their
careful positioning
suggests an intentional
diagramming of the
landscape to communicate
a message, perhaps both to
the ancestors and to the
builders' descendants.

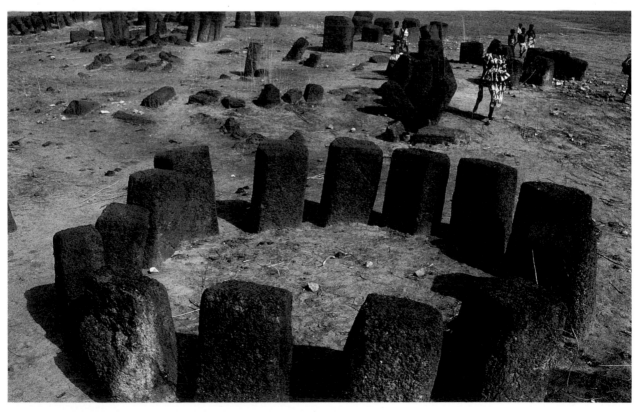

Fig. 5: Circle of stones, Zaose, Burkina Faso, 1982. Erected within and just outside Zaose compounds in Burkina Faso, small stone circles honor ancestors and attract spirits responsible for fertility and illness. Zaose children are known to sit inside these circles and eat honey, to attract the good fortune the spirits may bring.

ROBERT FARRIS THOMPSON: In Honolulu, in the Bishop Museum . . . I was astonished to find little green packets of pandanus and other leaves, carefully tied with pieces of rattan. When I talked to the museum staff and congratulated them on their incredible ability to go beyond simulating, a person said, "That's not simulation, *Kahuna* come in here all the time." . . . And [so] the Bishop Museum is simultaneously a series of discrete altars, a cathedral. Conversely, Nôtre Dame is definitely a museum/cathedral, because some of the people moving in and out of it—the tourists—are secular or agnostic or whatever, but simultaneously there are men and women who are using those altars It is possible, however fleetingly, to cathedralize, to altarize, museums.

away; a chief's home may disintegrate within a decade of his death, but will be marked forever by a tree planted there.

Both landscape and built space in Africa are often interpreted and mapped anthropomorphically or anatomically, referring metaphorically to the human body. In the identification of space with anatomy, and in actions, often performed at certain architectural and natural landmarks, that simulate or symbolically allude to bodily functions, spatial relationships are defined and remembered through the body (Blier 1987). The association of the body with village layout and with architectural design suggests the organic nature of space for some peoples, the anthropomorphism of a house providing a physiological mnemonic referent. And house and village may also have further meanings: "African architecture and village layouts often have been and sometimes still are important vehicles of religious expression. Round roofs, central poles, and rafters are often metaphors for the celestial dome and *axis mundi*; walls are often painted with sacred symbols; compounds may have special features that refer to religious principles or facilitate worship; and village layouts may reflect the aesthetics and harmonies of divinity" (Roberts forthcoming (b)).

Houses of Memory and Maps of History

In a discussion of the powerful effects that architectural spaces can have as loci for

the recall of memories, Gaston Bachelard describes how people "house" memories, how rooms come to host an unforgettable past. Nooks, garrets, attics, cellars, closets, and secret alcoves become places for the storage of knowledge and memory. For Bachelard, memory is localized and enacted through space, not time. The actual duration of the past can never be relived, only the thought of it: "Memories are motionless, and the more securely they are fixed in space, the sounder they are" (1964:9).

Bachelard calls the association of memories with intimate spaces "topoanalysis" (ibid.:8) The house we were born into is inscribed in us. It preceded our being in the world, it is outside time, and we return to it constantly as the singular, preeminent experience of habitation. The house and its rooms can in a sense be "read" as psychological diagrams of the subconscious (ibid.:38).

The Renaissance "memory theater" also shows how space can shape memory and consciousness (Yates 1966:129–159). The memory theater was a mental space designed to store knowledge: one imagined an architecture, its rooms crammed with shelves, drawers, and niches containing the information one wanted to remember. Static, this mnemonic device ironically subverted the usual temporal dimension of theater, trying to halt time instead of passing with it. Like theater, though, it preserved memory through artifice—theater being the supreme medium of artifice.

Museums are equally powerful, equally artificial houses and theaters of memory. If, for Bachelard, one's childhood home is the first or "original" building, for Robert Harbison the museum is the "last" building: as the first house is locked in our memories and subconscious thoughts, so museums seek "an end to change, a perfect stasis or stillness; they are the final buildings on earth" (Harbison 1977:147). Museums are often laid out spatially by time periods, so that a room comes to stand for a century, a gallery for a whole era; "Museums, by arranging history spatially, give us a chance to experiment with various sequences of remembering" (ibid.:142).

A museum becomes its own metonym, a universe unto itself, with its own narrative and history. To familiarize the visitor with the unknown dimensions of this space, a ground plan is often provided at the admissions desk; yet though "maps seem effective preservatives, . . . it is museums, Houses of the Past, which turn all they pick up to history. The act of museumifying takes an object out of use and immobilizes it in a secluded atticlike environment among nothing but more objects, another space

AYUKO BABU: One of the things that could be done [at the Museum], in terms of theater and active and passive, would be in terms of pouring libations. . . . There are some beautiful libation art objects that can be used. . . . Every morning or every afternoon when you opened the museum you would pour libations, and the young people would come and figure that they'd actually experienced and understood [African art]—and that it gives life.

JAMES CLIFFORD: What are the sounds of museums? . . . A specific kind of footstep, a museum walk. . . . If someone walks too fast through a room, it's disturbing. . . . A murmur of talk, occasional coughs . . . then the breaches of decorum—someone will speak too loud, everyone is irritated.

MAUREEN HEALY: We're specifically letting the viewer in on the framing issue that happens all the time in an exhibit in a subtle way. We sort of pull down the curtain Part of what's happening in the exhibit, . . . and part of what [viewers] were doing when they were looking at art, [is] selecting views. They could select other views, remember and combine selected views.

dele jegede: We have to think of performance, for example, which is an aspect we have consistently neglected when discussing museums—yet there's hardly any way to think about African art without thinking of performance. And performance is such that you cannot stay at one point, according to a proverb, and watch a masquerade. You have to go on and on with it as it stops, runs, moves—it's very elastic. And that elasticity is one concept I think we have to integrate into the whole concept.

James Clifford: To me the great thing missing in museums is sound. . . . Sound goes through partitions and walls, so you can't contain it the way exhibits create spaces for viewing . . . Sound messes that up terribly, so it's always seen as something intrusive and hokey—or Muzak. And yet, sometimes the excruciating absent sound of these objects . . . is so poignant. You know the piece in the Museum of Modern Art "'Primitivism'" show, the piece called "rhythm pounder" . . . A torso where the two arms make handles . . . How could you not want to get your hands on it and hit the dirt with it, hear its shape?

made up of pieces" (ibid.:140). Maps have their own kind of power, however, becoming in a sense more real than the territory they record and represent. When the empire has fallen, the map remains (Baudrillard paraphrasing Borges 1983:1–4). The idea of the museum as a map of human history, and a synechdochic substitution for it, is implicit to the museum experience, and suggests the power of museums to articulate and shape culture.

Architectural Time: Space, Room, Interval, Pause

A critical aspect of exhibition space in Africa is its temporal dimension: the ephemerality of its displays is partly what gives them value. In the museum, on the other hand, as John Conklin remarks, "The art works are always there; there is no event" (interview 1994). This is probably the way Western and African approaches to space differ the most. If Western museums turn time into space, then it might be said that African expositions turn space into time.

Exhibition spaces in Africa are adapted to the temporal dimensions of performance—the sequences of masks in a masquerade festival, the kinetic gesturing of a diviner in the state of possession, the slow-paced processions of rulers, the spirited songs for twins under the light of the moon in open town spaces, the climactic, long-awaited arrival of certain masks at dusk or dawn, the four-day containment of a king in a house. In Africa, space and time are inextricably and inseparably bound up in the exposition of art. Part of the challenge to the Western curator, then, is to reconcile the contradiction between the life African objects live in Africa and the freezing or capturing that takes place when they enter the museum and are sealed in the Plexi case. As Chris Müller writes,

> Not only does the museum attempt to remove the object from the flow of time, but its pretense is to halt, or at least to slow to imperceptibility, the changes that the object would experience from regular handling and exposure to the elements. The work becomes static, where it exists in frozen immutability, while the visitor comes and goes. The impression is created that the act of viewing the object will be the same every time one visits the museum, for the piece will not have changed one bit.[4]

It's not surprising that many associate the museum with the morgue and the

mausoleum. How can such a place be a living sanctuary for works, some of which were intended to mobilize and embody life force itself?

Yet the museum's sanctified space condenses time into the space of ritual. Profane time is ongoing, undelineated, continuous, uninterrupted; ritual time is constricted, bounded, delimited, marked off, magnified. The museum's fabrication of time, its delineation and demarcation of time, can lead to intense, even transformative experiences. The museum space re-creates time as something in our hands to invent.

The Architecture of Ritual: The Museum as Journey

The invitation to Maya Lin to design the Museum's new SoHo space in 1992, and her agreement to do so, affirmed a shared philosophy and aesthetic vision of the display and presentation of African art. Lin is not African, and has never been to Africa. But her previous works, notably the Vietnam Veterans Memorial, demonstrate a sensitivity to space, and an interest in a performative, journeylike experience of it, that seemed conducive to the presentation of African art in regularly changing exhibitions. By creating a space that evokes the experience of a journey rather than the fixed structure of a narrative, Lin has reinforced the Museum's practice of constantly throwing institutional authority and exhibition process into question. Her style is one of evocation rather than imitation, of empathy and affinity rather than literal borrowing. She accents color, lighting, pattern, and materials, and hers is a hand-crafted space, its asymmetry and human scale suggestive—though not imitative—of African uses of line, space, and design (figs. 6–7).

Lin's hand is evident only in the spaces projecting off the galleries or leading to them, and at the joints between inner and outer rooms, corridors, and passageways. She has left the galleries themselves more or less untouched—empty spaces within which meaning can express itself. Her work also appears in the shop, in the events room, and in the offices and stairways. With its hand-crafted display platforms and admissions desk, its niched display wall, and its rough-hewn benches (made from the floor beams that were removed to create the stairwell), the shop is the first area that the visitor confronts (fig. 8). A striking events room also radiates off the void—a startlingly beautiful sanctum of indigo-cloth walls, their tiny white

ROBERT FARRIS THOMPSON: I'd love to see dance docents. I'd like to see gesture docents. . . . And I'd also like to see some spotlights that spotlight people. Spotlights are only on the *objects*, and there should be double spotlights . . . so the art object is what it's meant to be in Africa: a *copresence*.

FRED WILSON: I want to give a sensory experience that we in museums really have not exploited at all. We're very much tied to intellectual experience and a very narrow, bogus visual experience. And when you're talking about contemporary Western art it's more narrow than when you're talking about African art, which really does have a much wider sensory importance. So it just seems that we have to . . . reeducate ourselves to those other kinds of processes that may not be so literal and may not be so linear. As one narrow interpretation or singular sensory experience is replaced by multiple ones, it will evoke for the viewer something much closer to what the object, image, or culture is about, for the very reason that it is more complex because multiple viewpoints or forms, "multiple lives" as Maya put it, are really the way we experience the world.

Figs. 6–7: Drawings by Maya Lin for the design of the Museum for African Art, 1992. Lin's drawings for the Museum demonstrate a journeylike conception of space, with special emphasis on passageways, thresholds, and stairwells. It is perhaps no coincidence that in the Yoruba language the word for "ritual" also means "journey" (M. Drewal 1992); the journey experience of a museum visit can be compared to a rite of passage, with all of the transitions and transformations that the word implies.

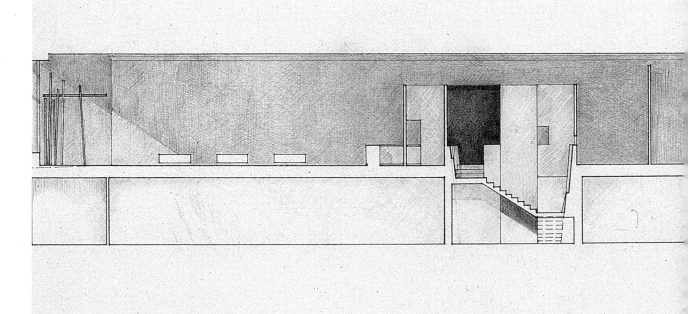

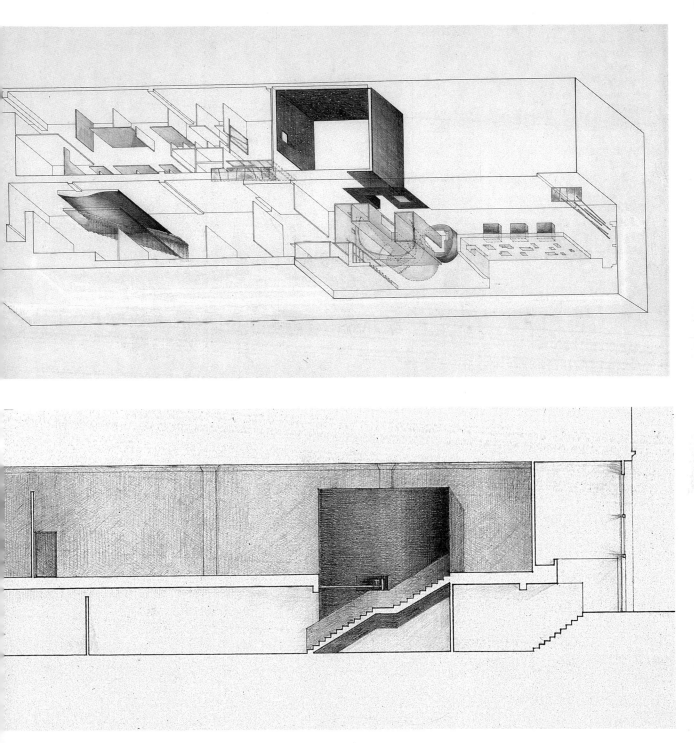

Fig. 8 (below): Admissions desk in the Museum for African Art, designed by Maya Lin, New York, 1993. Lin's handling of space, color, and form is subtle, evocative, and warm. It evokes some of the hues, tones, and perspectives of African architectural experience, without imitating any building in particular.

tie-dyes giving the impression, under the track lighting, of a galaxy, and creating a warm, otherworldly sensation.

The climax of Lin's design is the Museum's main stairwell, a bright yellow spiral that links the lower and the upper floors (fig. 9). As one passes from the admissions desk into the first gallery, one passes this stairwell, and one catches glimpses of its brightness through small rectangular windows—an indication of what is to come when one leaves, having circled through upper and lower galleries to find oneself climbing the yellow stairs to exit. Both front and rear stairwells, like the admissions desk, are based on Lin's hand-drawn designs, which no architect's mechanical tools could reproduce precisely, for they have a natural irregularity that is their beauty.

What is the interaction between a museum building and its galleries? The dialectics of inside and outside museum space are layered like the Chinese boxes of

Fig. 9: Spiraling staircase in the Museum for African Art, designed by Maya Lin, New York, 1993. The curved admissions desk and the staircase were hand-crafted to convey the natural irregularity of Lin's free-hand drawings that no mechanical tools could reproduce.

JAMES CLIFFORD: The visual bias, . . . the dominance of the eye at the expense of the other senses, has a history. And museums are part of that history. The act of visiting a museum . . . one might understand it in terms of a bigger history of travel. Then it's the body moving out of wherever it lives and going to a place to see something different or ennobling, ennobling in a sense possibly of sacred space, something like a pilgrimage.

ARTHUR DANTO : Especially with the kinds of things that you show, there's a lot more to them, to encountering them, than visual interest— whatever that is. But encountering power and magic, those are not visual qualities in any obvious way. . . . If what you do is encounter them visually, do you encounter them at all in the way they were intended? Or in a form of life that . . . explains their existence? If you did try to do that, it's not clear what you'd get out of it.

MAYA LIN: That's another thing: could you do something with . . . the artwork . . . not on display, so it only comes out at set times for a performance? So it is never [just] displayed That would be one way of really teaching people that this work does not exist except when it's being used in some kind of ritual—and that's when it should be viewed. And maybe it gets viewed once a week. . . . Why does it have to be static, seen seven days a week?

MICHAEL BRENSON: I don't think the permutations for installing or changing the way historical Asian works are seen are as great as they might be for historical African art. . . . I was wondering if it didn't have something to do more with the material, with stone, and with the kind of self-containment that was usually built into those monoliths of stone, and also the ideas of permanence that were built into them—the idea of really embodying in the stone, in some kind of very permanent way, a system of ideas and beliefs. And somehow wondering whether it wasn't a kind of mystic principle if you deal with wood, that wood is automatically connected to trees and villages and to the landscape.

the secret, and like the layers of the onion that lead to no core, no center. The outer layers include the block, the street, the sidewalk, the entrance. The primary interior layers involve passage through the shop and the bookstore, the admissions desk, the information desk, the coat check. Then there are the galleries themselves, within which there is foreground and background, and the seemingly impenetrable space of the Plexi box itself. The architecture of museum space encodes the secret, transparent but unreachable.

The Facade as Signifier

The facade of any building is a signifier for what the building stands for—its political and ideological messages, its history, its values. The facade is the museum's cover or envelope. Describing Japanese wrappings, Roland Barthes discusses how the outside, the container, is often more important than what is contained. This is also true of certain museums, where the architecture overshadows the contents: like the Japanese envelope, it "postpones the discovery of the object it contains—one which is often insignificant, for it is precisely a specialty of the Japanese package that the triviality of the thing be disproportionate to the luxury of the envelope" (Barthes 1982:46).

Not only is the facade a sign of the institution's character and contents, it is a signifier for a layered history of architectural use. Architecture rarely ends up being used only for the purposes that inspired its creation. Inscribed within the forms and facades of New York's SoHo architecture, for example, are the changing phases of the area's history—mercantile use, relative disuse, site of downtown bohemian culture, gallery boom, real estate boom, marketplace for all kinds of luxury commodities.[5]

For Labelle Prussin, the word "facade" needs revision if it is to be used in an African context, where it can mean a number of things: a building facade, for example, or something against which something is performed, such as street activity (Symposium comments, 1992). African museum professionals in a number of different sub-Saharan nations are seeking designs for buildings that will address the challenges of countries containing dozens and sometimes even hundreds of ethnic groups and language dialects. Boureima Diamatini, former director of the National Museum in Burkina Faso, for example, has discussed the politics of selecting a facade

for the country's national museum, and the ways mask forms have been appropriated for the facades of many government buildings in Ouagadougou.[6]

Any previously colonized country possessing colonial-period buildings has had to find ways, consciously or unconsciously, to change their form and use.[7] The participants in the 1992 symposium offered innovative suggestions for the facade of the Museum for African Art. One idea, proposed by artist Fred Wilson, was to have a daily market on the sidewalk outside the Museum entrance, like the markets on 14th Street and 125th Street, which resemble the markets of many communities throughout the non-Western world. Another suggestion was to have graffiti on the sidewalk in front of the Museum, or on the lobby floor inside the Museum, drawn to "spill out onto the sidewalk" (Maya Lin and Carol Duncan, Symposium comments, 1992).

Inside, Outside, and African Vision

Architecture creates a dynamic between the interior and the envelope, the container and the contained. Within the museum space, the dialectics of inside and outside become more complex as the space separates the viewer's body and gaze from the artworks themselves. These dialectics are made all the more explicit in a museum of African art, where a built-in distance separates the American museum-goer from the cultures on exhibit. Who is inside and who is outside? "Installation involves a convoluted geometry which entangles the division between interior and exterior, between subject and self" (Colomina 1992:121). Furthermore, the Western-biased conventions of exhibition installation often don't lend themselves to African modes of perception and viewing (fig. 10).

Modern Western culture, and particularly "exhibition culture," has placed a premium on vision above the other senses. An ocularcentric bias characterizes modernity (Foster 1988:3), and few museums as a result cater to any of the senses besides sight. Museums and exhibitions strive to isolate vision by creating a serene, hypothetically sublime atmosphere in which the other perceptions are muted, even effaced. That visitors to a museum come to "see" the things on display, to "view" the holdings, restates the dialectics of inside and outside: museum experience is about the relationship of viewer to viewed, and vice versa. The principal question raised

It seems to me that may automatically be a good deal more elusively contextual and ephemeral than stone. . . . Stone may be more intrinsically urban and architectural.

JOHN CONKLIN: I think I prefer architecture so much more than art, because it's so much more of an event—to walk around in, to experience changes, and things opening up, sudden shifts. There's something so boring about paintings. Maybe it's frames—the gold frames drive me berserk. . . . Maybe that's the problem with museums: the stuff is always there. There is no event. We remove the work from a performance and set it in a static situation. . . . This new perspective can be interesting, but the art has been taken out of a flow of time and the specific way its original energy was meant to be released is distorted. The blockbuster shows, limited in time, really come closer to theater. They become events that exist in time. . . . Architecture is always there, too, but it changes with time, with weather, and shifts as you walk around, through. But art in a museum is just there, set up under the lights, removed from time.

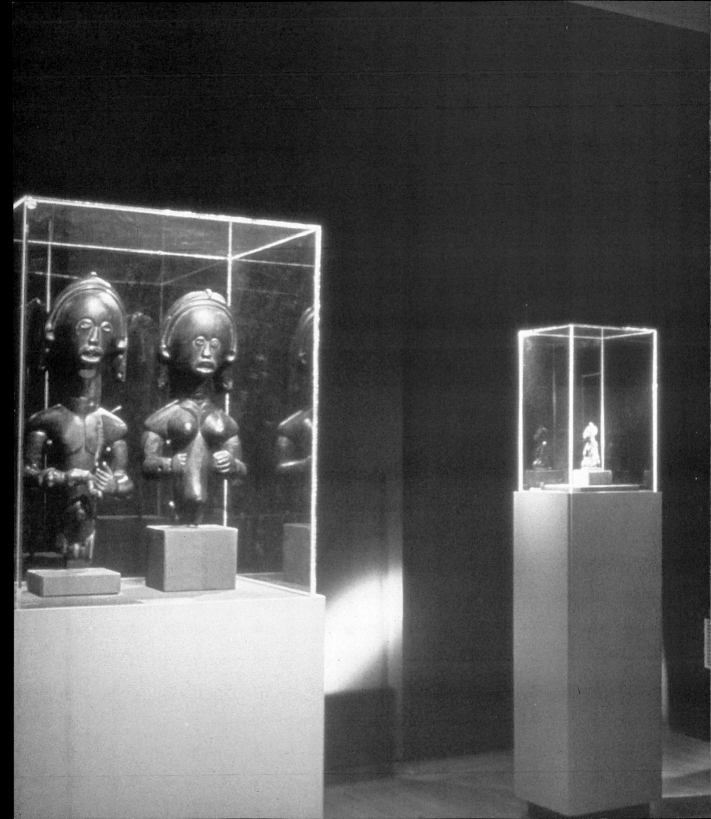

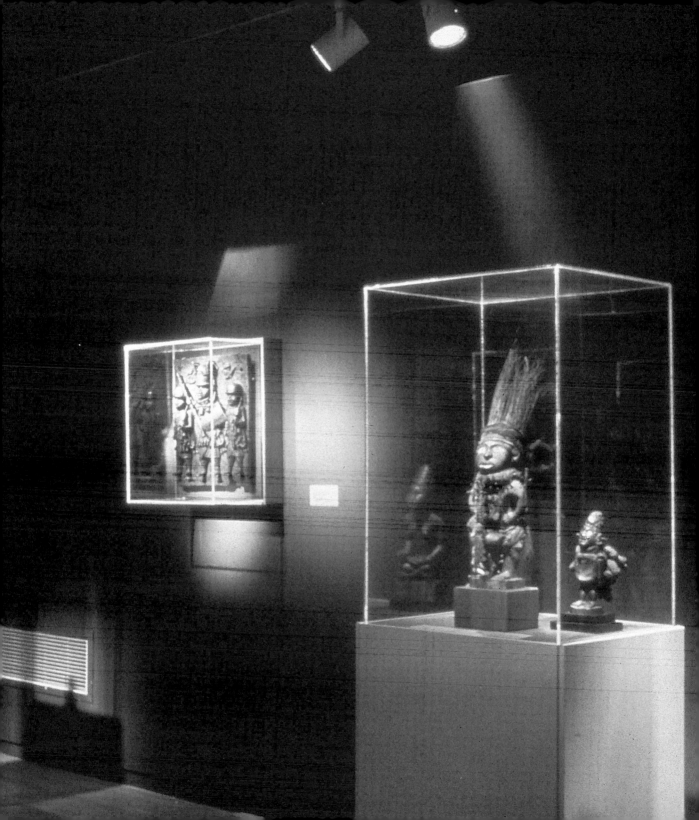

Fig. 10: (previous page)
African sculpture installed in
the "The Past in the Present"
section of "Africa Explores,"
the Museum for African Art,
New York, 1991. Plexi
cases and spotlights create an
aura of preciousness and
inaccessibility—the objects
gleam like jewels in a Tiffany
window. The conventions of
museum exhibition underscore
the dialectics of inside and
outside, whereas African
display styles tend to involve
changing vantage points,
shifting light, and ephemeral
boundary markers. How
might museums subvert the
Plexi boxes to achieve a fluid
passage that would blur the
distinction between inside and
out, emphasizing the
differences "within" rather
than the differences "between"
our selves?

MAYA LIN: Think about an art
exhibit as being a vision. And it
gets to opening day, and then
the book's out—but what
about from the opening dates
to the time it closes? Focus on
that. We always focus on the
front end—and we walk. The
curatorial conversation ends
there. What if it were to
continue?

by "Exhibition-*ism*" is who is looking at whom, and who is being looked at. The museum is in general a place of surveillance: there are cameras and guards, and staff members walk at random moments through the galleries. Museum-goers themselves often take as much delight in viewing fellow museum-visitors as in the works on display.

Many works of art and architecture in Africa, on the other hand, were not originally intended to be looked at carefully, an action often associated with witches, sorcerers, and other persons of evil intention (Nooter 1993:236). Discussing the importance of demureness in Mende aesthetics—expressed in masks with downcast eyes—Bill Murphy recalls a Mende proverb which states that "Beauty is best perceived from a distance."[8] Many African artworks are intended not for direct, head-on scrutiny but for partial or peripheral viewing, or to be viewed in motion.

Furthermore, when objects are intended to be looked at, they are often presented at levels beyond the usual seven-foot-high framework of sight that focuses the eye in Western museums. Stilt dancers and shrines built at ground level are instances of art forms intended for viewing, but viewing in the most unlikely of places and spaces, viewing where viewing is least expected—from a Western perspective. Robert Farris Thompson has described Cuban Leopard Society altars and Vévé dance platforms in which all sides and views are available for display.[9] Floor, ceiling, and walls are all key elements of the artwork (writing being inscribed on the floor, for example), which thus appears on varying levels and heights.[10]

The Sanctified Box

Museum vitrines and Plexiglas restate on a more intimate level the problem of distance, of who is being looked at and who is looking at whom. Artworks may require the protection of glass-enclosed spaces for humidity control and protection from handling, touching, and theft, but these cases exacerbate the distance that already separates the viewer from the object. How can that distance be bridged? Does the presence of museum guards increase the aura of distance and preciousness? If the Plexi were removed, would it change the experience, or would it simply diminish the supposed value of the works? As Chris Müller writes,

> What is the meaning of the vitrine, the glass or Plexiglas case? . . . The
> vitrine is a necessity for reasons of conservation, insurance, and the mistrust

in the visitor, who might not be able to control an urge to touch the enticing piece. It implies value, a worth that merits at least this measure of protection, that could be further accompanied by alarms set off by broken light beams, perhaps a nearby armed guard. The visitor is informed that he or she may inspect the work, but not share the same space with it. The vitrine is in a sense a window, through which the visitor may view . . . the production of a distant culture.[11]

Foreground/Background

One of the most important aspects of museum experience is the separation of foreground from background. What is supposed to be at the center of our attention? When we pass through the shop, say, to get to the museum, see the books before we see the exhibitions, what experience is foregrounded? How does the viewer distinguish what is for sale from what is on view within the museum?

When a museum is mapped by rooms, each room representing a culture, era, or style, it is up to the viewer to discern which rooms are emphasized within the museum's narrative, and which objects are preeminent within those rooms. But the viewer's decisions are aided and abetted through choices made by curators and effected by designers and lighting technicians, who work to develop a sense of perspective within the museum landscape. Lighting, for example, is a powerful tool. A single spotlight above an object can almost suggest that it is lit by God. A large number of light sources, on the other hand, erase mystery, and eliminate the suggestion of a single point of view.[12] When the lighting invites the viewer into the same space as the object, the work is desacralized; when the lighting suggests a separation or boundary line between object and subject, the work is sanctified.

No matter how flat, no matter how diffuse, lighting is never neutral. It has always been determined by someone—it is always intentional. Lighting has long been recognized as a powerful expressive signifier in cinematography and in theater; it is generally used less flexibly in museum practice, which tends to strive for a scientific aura of truth, and therefore has avoided dramatic approaches to shadow and contrast. But it has to be recognized that the evenness of museum lighting reflects not so much a failure of imagination as the creation of a deliberate effect.

MICHAEL BRENSON: I think that part of the attraction of a place like the Met is that they are always there: the paintings are there, the Egyptian works that I grew up with. You know where they are, and you can always go back to them, you can count on them. There is something reassuring about that, but also something extremely dangerous, particularly when it implies fixing or freezing cultures whose full complexity and humanity have been violently denied by Western institutions for so long.

MAUREEN HEALY: Maybe history is just too ambitious a story, and that's why it sometimes fails. Stories, on the other hand, shouldn't be thrown out, because history often fails, especially with exhibits. This may hold true for stories in general—that the shorter the story, the tighter the focus, the smaller the subject, the more truth can be contained in it.

ARTHUR DANTO: At one point art and science were connected for the betterment of society, and now it's not so clear

Text: Authorizing Truth

The use of text in museum space is another powerful tool in the signifying process that is exhibition culture. Text usually acts as a mediator, translator, or interlocutor between the viewer and the object. To frame an object by writing is to imply that the viewer will be unable to comprehend or fully assimilate that object without help. To let the object stand by itself, on the other hand, may suggest that its meanings are self-evident to the viewer of discernment and refinement—an often alienating tactic.

Writing, in any case, doesn't necessarily assist comprehension but may in fact stifle it, for the conventions of writing are such that they reinforce cultural specificity. A process of translation is at work in labeling. Some labels may divulge information that in Africa would not have been meant for public consumption; artists' names and the materials of the artwork are sometimes considered to be secret information. Other labels may contradict the ethics and aesthetics of African modes of transmitting information. What if the text defined the space? Or was the space? What if the text was spatialized, placed on the floor so that you had to walk over it (as in some installations by the contemporary artist Barbara Kruger), or covered every wall around the object on display? Could words be avoided altogether? Is the experience of art dependent on textual aids, on language and writing? How does writing authorize an exhibition?[13]

The Space of Encounter

The conventions of Western museum exhibition underscore the dialectics of inside and outside in ways that run counter to most forms of African display and exposition, which emphasize changing vantage points, shifting light, and ephemeral boundary markers. How might museum exhibitions subvert the Plexiglas, the spotlights, and the text, to achieve a fluid passage that blurs the distinction between in and out, and emphasizes the differences "within," rather than the differences "between?" How might exhibitions of African art avoid a "rigid self/other dichotomy which serves to draw attention away from historical interactions between groups as well as differences within them, which encourages the reification of 'culture,' 'ethnicities,' and geographic regions, and which ignores the ways in which 'selves' always require an 'other' for self-definition?"[14]

The encounter between the spectator and the object is experienced as a performance, and the challenge behind exhibition and museum design is therefore to create a space that can accommodate and contain the energy of the performance. Yet there are no performers in a direct way. Rather, this is a "displaced performance," where the act of creation has taken place at some point in the past and can be mentally re-created through the spectator's gaze and sensing body.[15] Museum settings provide labyrinthine spaces for the enactment of performance, with their complex geometries of interiority and exteriority, of time and space, and subject and object.

The on going mission of the Museum for African Art is to experiment with ways of heightening the level of that experience, while always striving to come closer to an understanding of the works, their makers and users, as well as the "'secrecies of encounter'—those points of contact, namely colonialism and an international art market, under which the exhibited objects were produced and by which they have reached their Soho destination."[16]

1. For a discussion of mimetic and metonymic displays, see Kirshenblatt-Gimblett 1991:388–389.
2. As Robert Farris Thompson has described (1993), this practice extends to the African Americas, where altars can be found in laundry bins, closets, beaches, yards, and vehicles—a range of sites different from but no less startling than that on the African continent.
3. Susan Vogel, personal communication with the author, 1994.
4. Chris Müller, personal communication with the author, 1994.
5. Müller, personal communication with the author, 1994.
6. Boureima Diamatini, symposium comments, 1992.
7. Fred Wilson, personal communication with the author, 1992.
8. Personal communication with the author, 1992.
9. Thompson, personal communication with the author, 1990.
10. An exhibition, "Gods, Guardians, and Lovers: Temple Sculptures from North India, AD 700–1200," held at the Asia Society, New York, March 31 - August 15, 1993, explored the effects of sightlines by exhibiting Indian temple art as it was intended to be seen—either very high up or very close to the ground. Laura Scanlon, personal communication with the author, 1994.
11. Müller, personal communication with the author, 1994.
12. Müller, personal communication with the author, 1994.
13. An exhibition entitled "The Label Show: Contemporary Art and the Museum," February 12–May 1, 1994, organized by the Museum of Fine Arts, Boston, experimented with the conventions of labeling and interpretive texts that accompany objects in many museums today.

JOHN CONKLIN: This is what I want to know: why is to call something theatrical to denigrate it? Why does it mean cheap, fake—instead of realizing that it is the truest metaphor for life? Life is performance, settings, costumes, scenes. Art is theatrical.

MAYA LIN: I think art is something that you live with and that you enjoy, and the second you move it into some . . . monumental experience, the distance is made. . . . And it is a very politically ordered situation. The second you walk into that temple, the second you walk into that museum, it will tell you what your relationship is to the object. And . . . sometimes I sort of agree: . . . the best museums I've seen weren't necessarily designed as museums.

14. I wish to thank Christine Walley for providing me with a manuscript of a graduate paper she wrote entitled, "Art Battles the Ethnographic: The Secrecy Exhibit at the Museum for African Art," 1994, from which this quote was taken.

15. These ideas were conveyed to me by Chris Müller from conversations he had with Richard Schechner on the subject of exhibiting.

16. Christine Walley citing Barbara Kirshenblatt-Gimblett, 1994.

History of a Museum, with Theory

Susan Vogel

IF THE MUSEUM FOR AFRICAN ART has ancestors, if it fits into a genealogy of exhibition approaches to African, Oceanic, and other arts deemed related, its closest relatives are all in New York. Immediate next of kin would be the Michael C. Rockefeller Memorial Wing at the Metropolitan Museum of Art, which opened in 1982, and its parent, the now-closed Museum of Primitive Art, which opened in 1958. Both were guided by the design ideas and tastes of Douglas Newton, who directed them both at different times, and for whom I worked in both institutions. Newton's approach was shaped by his association with René d'Harnoncourt,[1] of the Museum of Modern Art, who in turn represented a link to the Modern's important "African Negro Sculpture" exhibition of 1935, which had presented African sculpture solely for its aesthetic merit. That show had had a remote pioneer forebear in an exhibition of 1914 at Alfred Stieglitz's 291 Gallery, on lower Fifth Avenue. Stieglitz's exhibition is recognized as the first in America to take the course followed by the exhibitions and institutions in this lineage: to present African art as art.

Ever since Stieglitz demonstrated what an "art" exhibition of African objects might look like, American museum presentations of these works have been directly or indirectly shaped by the Western debate over whether to approach them as art or as artifact. At the turn of the century, African art was securely lodged in museums not of art but of natural history, as indicated by the exhibition list above, gradually

> BARBARA KIRSHENBLATT-GIMBLETT: [An] exhibition is a lens, it has a way of looking. That's the point of it.

Fig. 1 (opposite page): Entrance to the Center for African Art during its first exhibition, "African Masterpieces from the Musée de l'Homme," 1984. The East 68th Street building had been constructed as a private residence, and had been maintained as one until the Center took it over. The small entrance led to five galleries on two levels, divided between this building and the one on the right.

entered the art museum, at first as an interest of the avant-garde, later as a key ingredient in the formation of modern Western art, and finally as a worthy art tradition in its own right. Yet its place in art museums has been repeatedly challenged, usually by the sectors of its ever widening audience who have encountered it most recently. Obviously the exclusion or inclusion of African objects from the canon of world art has complex political ramifications. Recent iterations of the debate have included the response to the "'Primitivism'" exhibition at the Museum of Modern Art in 1984: the fact that most African languages don't have words that correspond to the Western notion of "art" concerned some visitors, who questioned whether African objects can properly be considered art (some of them perhaps seeking to put African art in its place, others wondering whether the term "art" actually did it justice). Another recent challenge has come from young African scholars who also challenge the description of sacred objects as "art" and who doubt the ability of Western institutions or scholars to deal objectively with African artifacts. They assert that since these objects don't fit Western categories, Westerners cannot understand them.

The Museum for African Art has taken the position that though African objects do indeed spring from contexts in which contemporary Western definitions of art are alien ideas, they are no different in this from objects of many other traditions represented in art museums. Art museums are Western institutions that select their exhibits by their own criteria—which may or may not correspond to those of the objects' makers. It is worth recalling that almost nothing in the vast Metropolitan was made to be exhibited in a museum, including most of its Western painting and sculpture. Museums have come to house a multitude of things—Egyptian sculptures, Paul Revere silver coffee-pots—that at another historical moment would have been installed in tombs or pantries. Now, the museum seems their natural habitat. African sculptures, however, have so recently arrived in museums that they still look out of place there, and invite the question of whether or not they belong.

Ultimately, it probably doesn't much matter whether one calls African objects art or artifact. Whether their ability to fascinate and move people who are remote from the original process of their creation is due to their expressiveness, to their formal characteristics, or to some abiding spiritual dimension, the important fact

remains: a small fraction of all the objects people have made continues to arouse and satisfy human cravings, in ways unrelated to those objects' original meanings, long after they have left their original contexts.

In Africa too, members of some traditional societies collect and preserve certain—not all—archaeological objects they find. And the types of objects they treat this way are the types most likely to be collected by Western museums. The Mende and Temne of Sierra Leone collect stone figures made by earlier populations, and place them in shrines. People all across Africa collect and tend the neolithic stone celts that they may accidentally discover. Celts, gathered from the ground, are likely to be attributed with magical powers, yet other, equally interesting, but less "artistic" finds—pottery shards, for example—rarely get the same attention.

IN MUSEUMS THE ART/ARTIFACT debate has most often resulted in either an aestheticizing display, with little information provided, or a contextualizing display, with copious text and pictures. On the aesthetic side, the dichotomy is also expressed by the elimination of certain categories of object (nonfigurative objects, "crafts"), and by a certain prettifying of the objects themselves—by removing raffia and other attachments, for example, or by cleaning and polishing. For many years one of the clearest differences between the two camps has been the approach to labeling. This issue is now part of a wider debate on the provision of information in art museums: American museums have been more inclined to see themselves as having an educational mission than European museums, though it is still common in America for permanent displays of paintings, and for exhibitions of contemporary art, to be accompanied by only the scantiest information.

As long ago as 1931, the directors of museums in Frankfurt and Hannover engaged in an extended debate in print on this issue, staking out the two extremes of the argument. Asserting that suggestions of the historic settings of artworks, and other informative material about them, prevented the observer from really seeing the work itself, one of these men insisted that the proper function of the art museum was to allow the artwork to quicken the human senses and imagination. The other dismissed this approach as romantic, and stressed the museum's educational, life-improving responsibilities.[2]

whether it be art or architecture, then the very idea of museum heritage is irrelevant and inappropriate. Similarly, the basic tenets of Western architecture, e.g. Vitruvius' permanent and sedentary structures, are irrelevant for much of African architecture, such as buildings of earth or nomadic tents.

JEAN-AIMÉ RAKOTOARISOA: I am always astonished by the fact that we have as our point of departure the idea that African art is a primitive art. If you do an etymology of the word "primitive," you'll see that it simply means "first." [But] in all the museums . . . the so-called primitive art is always exhibited at the end. . . . So the desire that I'd like to express today is that in future museums, you should reverse that process: that is, begin with the so-called primitive art and then end with the Western.

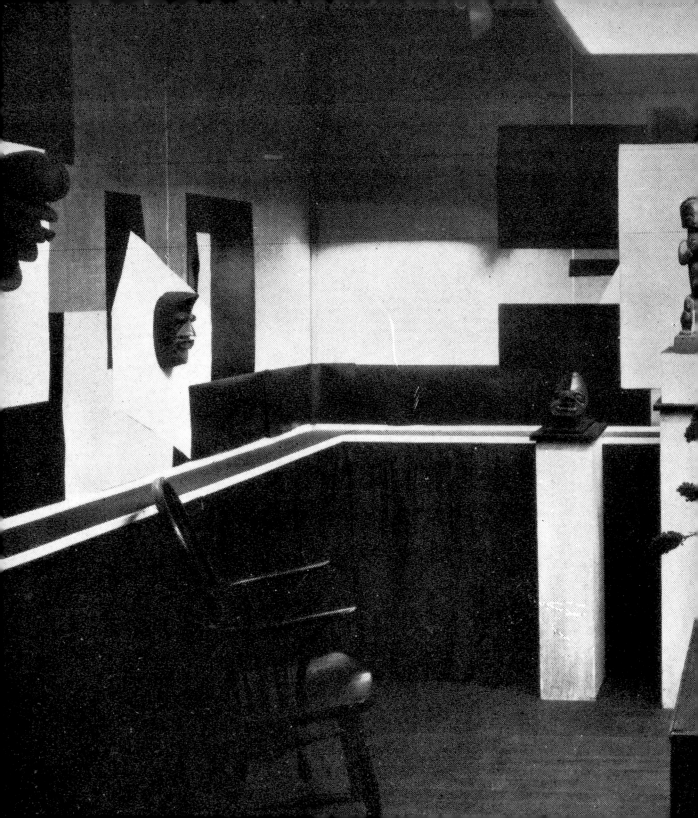

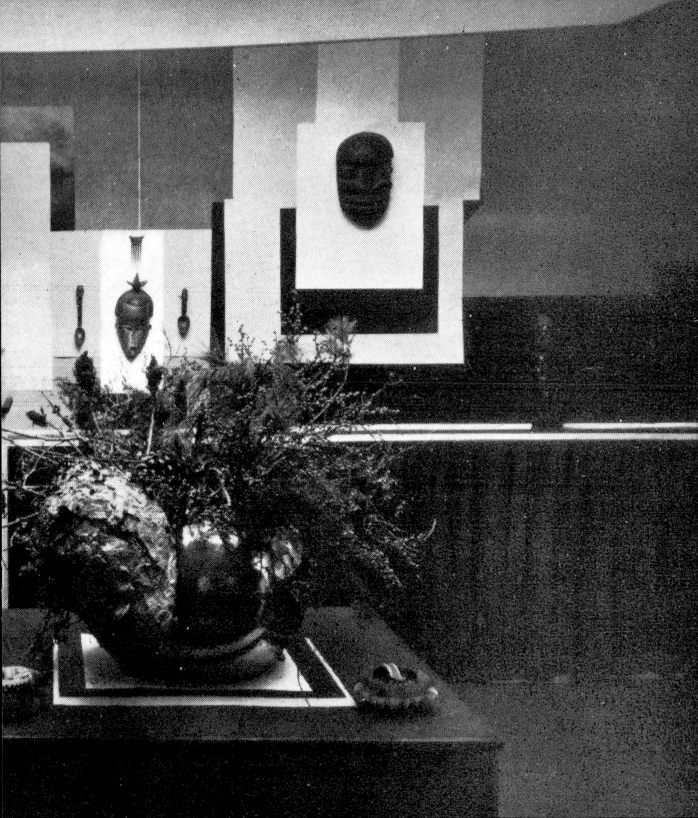

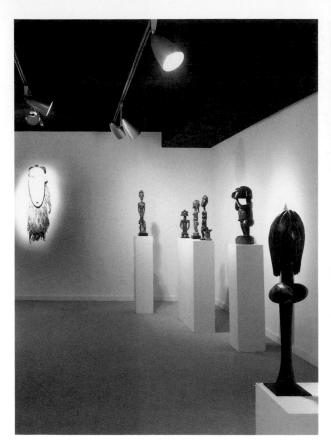

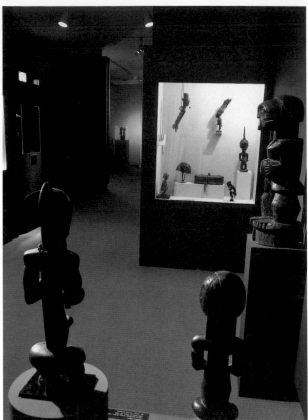

Fig. 2 (previous page): African objects as installed by Alfred Stieglitz in his 291 Gallery, New York, 1914. Stieglitz used a modernist design vocabulary that recalls Cubism and suggests a search for pure forms in the African works, which have been shorn of any visual reference to their origins.

Fig. 3 (above left): Installation of the exhibition "African Sculpture Lent by New York Collectors," the Museum of Primitive Art, New York, 28 May–11 October 1958. Upper floor, rear gallery. In this exhibition, the feeling of immediate intimacy with the sculptures was enhanced by the display of all but the smallest pieces in the open, without Plexiglas. Dramatic lighting and strong wall colors were often used in the 1960s and '70s.

Fig. 4 (above right): Installation of the exhibition "The Gustave and Franyo Schindler Collection," the Museum of Primitive Art, 2 November 1966–5 February 1967. First floor, front gallery. The installation, organized without reference to African geography or any other nonformal consideration, implied that the works should be approached through a modernist sensibility. The catalogue reinforced the emphasis on form over content: it had 52 illustrations and only 200 words of text.

Fig. 5 (opposite page): Installation of the exhibition "The Gustave and Franyo Schindler Collection," the Museum of Primitive Art, 2 November 1966–5 February 1967. Lower gallery. The spare, elegant installation style, with its slender pedestals and no vitrines, was the antithesis of the dowdy displays common in natural history museums at the time.

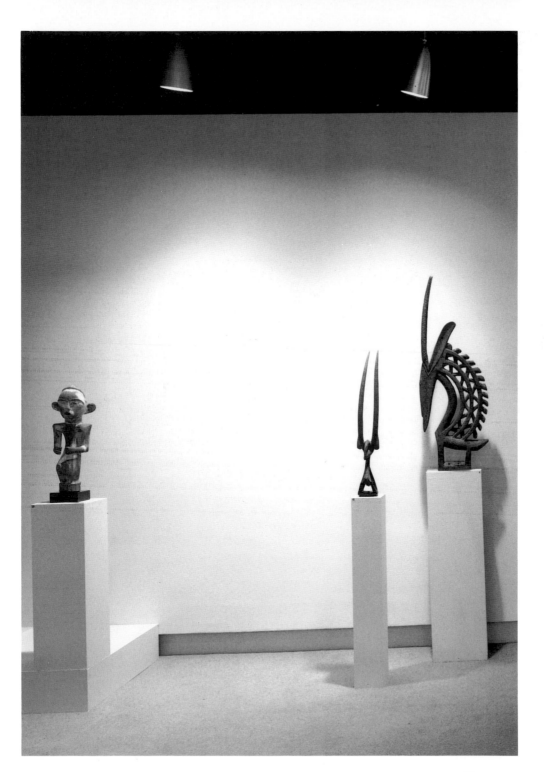

In 1914, when Stieglitz presented African sculptures at 291 (fig. 2), he juxtaposed them with avant-garde work from Europe. His gallery's small audience was generally prepared to accept both these noncanonical groups of works as art in the most advanced sense of the day. That audience, and the architecturally neutral space of 291, afforded him the opportunity for a new installation style—unornamented, straight-lined, and modern, with a clean grid of panels framing the sculptures. This fundamentally aesthetic exhibition announced itself and its contents as harbingers of a future radically different from its present.

No installation photographs survive from the Museum of Modern Art's 1935 exhibition, but it seems to have been installed in exactly the same style as all the Modern's other shows of the time. The museum's audience, though small and elite by today's standards, was much broader than Stieglitz's, and included reviewers from the news and art presses, an intelligentsia prepared to accept the African objects as artworks. The main message of "African Negro Sculpture" could be read in the installation style, and in the entrance of these works into the building itself: placement in these galleries proclaimed that African art not only was related to modern art, but stood on equal ground. The premise was reinforced by the presence in the galleries of many of the great icons of African art in European museum and private collections. The catalogue text—by James Johnson Sweeney, who curated the exhibition—is a ringing call to recognize the greatness of African sculpture as sculpture, and to consider it solely "from the aesthetic point of view." Opposing himself to the anthropological displays of the natural history museum, Sweeney stated that information would get in the way of looking and appreciating, his main goals.

By the 1950s and '60s, American museum audiences had grown to include a more various social mix, ranging from sophisticated European-educated émigrés, refugees from Hitler, to the first generation of Peace Corps volunteers who had worked in Africa. Almost no art museums had collections of African art at the time, and those that did all seem to have exhibited it in the basement.[3] This was probably in part a function of available space, and of the fact that the African art was often the most recently arrived segment of the collection. The basement location, however, often on the way to the cafeteria or the bathrooms, carried an unmistakable message:

"primitive" art might be art, but it was less prestigious than other art, and peripheral to it.

The display style tended to distinguish itself from that of anthropology exhibitions, mainly by aestheticized presentations that supplied minimal information and focused on types of objects that seemed to correspond to those of the "high" art traditions. Masks and figures dominated. During the 1960s, however, museum audiences began to demand more information, not just about African art but in general. The introduction and success of audio guides was one sign of this growing demand. Meanwhile, art books on African art began to be published regularly.

After both the Museum of Modern Art and the Metropolitan Museum had declined to acquire his "primitive" art, Nelson Rockefeller founded a museum based on his own small collection of African, Oceanic, pre-Columbian, and Native American art. This was the Museum of Primitive Art, initially called the Museum of Indigenous Art—either name a manifesto and a challenge to all those who would relegate its contents to the natural history museums. This institution's exhibition style was as radical as the premise it embodied. The Museum of Primitive Art showed its objects for their own inherent qualities, setting them on pristine walls and slender, clean-lined pedestals (figs. 3–5). The labels carried minimal information, identifying only style or origin. Its displays asserted that "primitive" sculptures were art, on an equal footing with all the other great art traditions—that their forms were as "ideal" and "universal" as any others, and could be appreciated on their own, with no further bolstering—unlike anthropology museums, which had long set objects in didactic displays as a means to illustrate entire cultures.

The museum was located on West 54th Street, opposite the Museum of Modern Art garden, in an elegant pair of Beaux-Arts townhouses that gave it automatic prestige (to say nothing of the patronage of the governor of the state, a man whose name was synonymous with wealth). A renovated interior provided neutral, modern-feeling space. The Museum of Primitive Art attracted an audience that was for the most part already convinced of the institution's founding premise. Though by the 1960s its collection contained thousands of objects, it never maintained a permanent installation, but kept about a third of its objects out on loan to other museums, and presented about three temporary thematic exhibitions a year.

JAMES CLIFFORD: The line between museum and theme park is a fine one—and it's a highly moralized class line. Museums do not wish to be theme parks.

ARTHUR DANTO: I still feel that a lot of . . . museums are the only thing . . . in a given community, and if there's a decline . . . it is indicative of some loss of confidence, some loss of faith.

CAROL DUNCAN: Museums do not simply resemble temples architecturally, they work like temples, shrines, and other such monuments. Museum-goers today—like visitors to these other sites—bring with them the willingness and ability to shift into a certain state of receptivity. And like traditional ritual sites, museum space is carefully marked off and culturally designated as special, reserved for a particular kind of contemplation and learning experience, and demanding a special quality of attention.

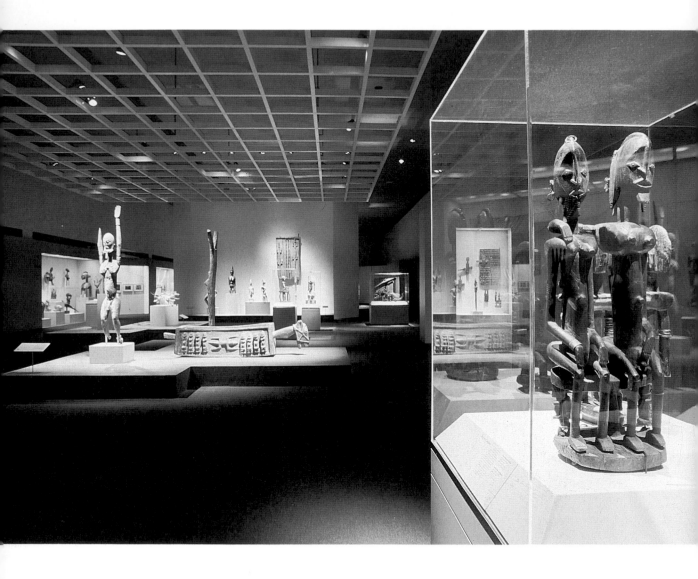

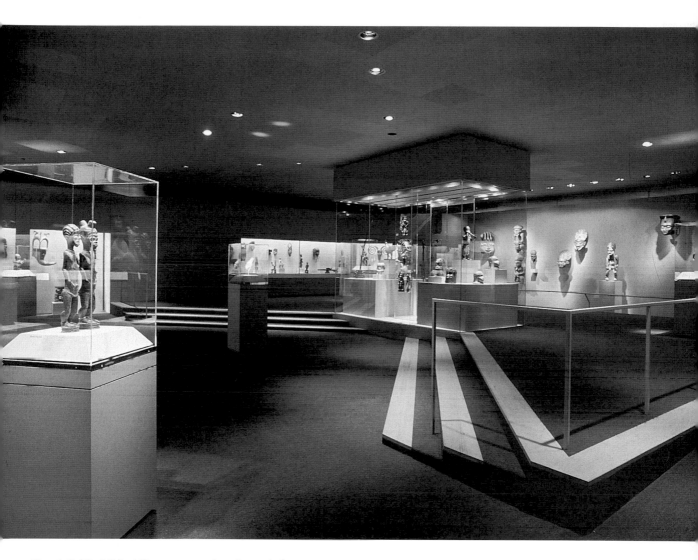

Figs. 6–7: The Michael C. Rockefeller Wing, Metropolitan Museum of Art, 1982. In the section of the Wing on the left, the ceilings are lower, the spaces smaller, than elsewhere. Large wall cases, the only practical solution to putting a large number of objects in a vast, unarticulated space, prevent the visitor from seeing the objects in the round.

FRED WILSON: These issues [cross] many lines with contemporary Western art. I would say that while the history of museums has been really class based, and how we interact with museums really is involved with class, the actual making of art in Western society has not had to do with these same issues. It's been placed within that environment and fitted into those categories. . . . The museum community right now . . . is thinking about these very same issues with Western contemporary art. So it's really . . . a more global issue.

These were all aesthetic in orientation, but moved past this basic message to explore given styles, collections, or topics.

A decade after its opening, the Museum of Primitive Art's collections were committed to becoming the permanent installation in the Rockefeller Wing at the Metropolitan, which was some fourteen years in the making. (figs. 6–7) Despite its apparently encyclopedic mandate, the Metropolitan had existed for a hundred years without feeling the lack of "primitive" art, and its staff and trustees shared no overwhelming consensus that African art belonged there, or even that it was art.

Fig. 8: Oceanic art as displayed in the Folkwang Museum, Essen, Germany, about 1930. Only less sophisticated security measures distinguish this approach from that followed in the Rockefeller Wing over a half century later.

CAROL DUNCAN: I treat art museums as ceremonial monuments . . . to emphasize the museum experience as a monumental creation in its own right, a cultural artifact that is much more than what we used to understand as museum architecture. Above all, a museum is not the neutral and transparent sheltering space often claimed for it.

There was even less conviction that it expressed complex ideas, or that it belonged to articulated aesthetic systems.

The Metropolitan's radically different building, context, and audience made the Museum of Primitive Art's kind of exhibition impossible, even incomprehensible. At the time of its opening in 1982, the most basic questions still went unresolved: how did African art fit into the history of world art? Did it belong somehow at the beginning of the sequence or at the end, alongside modern art? In the Metropolitan's layout it was juxtaposed with the art of early Greece, a vanished culture at the foundation of our own. Was "primitive" art also part of the foundation of our late

twentieth-century art? Where the Museum of Primitive Art's audience of repeat visitors had allowed curators to build on previous exhibitions, the audience at the Met needed to learn the basics of African art. Every day and forever there would be a visitor who had never seen an *ibeji* before—who might be intrigued, even thrilled, by the idea of sculptures for twins, but who would need the idea explained.

In retrospect it is clear that the Wing was conceived and installed defensively.[4] The selection concentrated on figurative sculptures, including virtually none of the rough or minimally worked object types that could easily be challenged as unworthy of the nation's greatest art museum. In the African section, only one textile was exhibited, and one pot, and no drums or spears. As in Stieglitz's exhibition of nearly half a century earlier, fur, feathers, and raffia were kept to a minimum. The installation's civilized, reassuring beige casework, and its prominent position on the main floor, would quell, we thought, lingering arguments against the validity of African art as art.

During the years of preparing the Rockefeller Wing, we discussed including large photomurals, and playing African music in the galleries. I opposed these ideas, because I felt that in the context of the other installations in the building, they would have conditioned perception of the African galleries as an anthropological exhibit. On the other hand, I would have welcomed the addition of music and contextual devices to the galleries of Dutch painting, say, or of arms and armor. I would then have been happy to see the same in the African galleries.

The Metropolitan's audience includes both some of the best- and some of the least-informed museum-goers in the city. In some measure, their doubts about African art were answered by the space, and by the mere presence of African art in the museum—despite the continuing use of the misleading and by then inappropriate appellation "primitive." The very broad range of visitors who would come to the Wing, the wide variety of needs they would expect to satisfy, and the knowledge that the average life of a "permanent" installation was upward of fifteen years demanded the most neutral and unchanging of presentations. We relied on straight geography.

When the Center for African Art opened its first exhibition, in a pair of renovated townhouses on East 68th Street in the fall of 1984, the dialogue changed. While the kind and quality of the objects exhibited were the same as at the

Metropolitan, the audience and the building were profoundly different. No longer a broad cross-section of the city's population, visitors were self-selected as motivated to seek out a museum dedicated to African art. These were the converted, so to speak, so it was unnecessary to persuade them that what we exhibited was art. (In any case, the much-publicized opening of the Rockefeller Wing had gone a long way toward laying that question to rest.) The buildings carried a reinforcing message of their own: we did not disguise or contradict their turn-of-the-century, domestic feel, their suggestion of the intimate surroundings of an aesthete. The displays did not address the political implications of that suggestion—privilege, exclusivity, and perhaps the hint that the African objects had been captured from their rightful owners—these were subjects for the 1990s. But freedom from the need to convince people that what we exhibited was art resulted in the inclusion of objects for the first exhibition that never would have made it into the Rockefeller wing.

1. René d'Harnoncourt was not yet at the Modern in 1935, but he curated two important successor exhibitions there on non-Western art, "Indian Art of the United States" (1940) and "Arts of the South Seas" (1946).

2. They were Georg Swarzenski, director general of the Museum of Frankfurt, who later served at the Boston Museum of Fine Arts, and Alexander Dorner, director of the Landesmuseum in Hannover, and later director of the Rhode Island School of Design Museum. It was Dorner who favored the educational approach. (Cauman 1958:95).

3. The Brooklyn Museum was a notable exception. It had acquired its first African objects around 1900 and, under the direction of curator Stewart Culin, began collecting more actively in the early 1920s. It kept a small but growing part of its collection on display, and since 1903 had had a Department of Ethnology. (Renamed six times, it is as of 1993 the Department of the Arts of Africa, the Pacific, and the Americas.)

4. The designer in charge of the project was Stewart Silver, who worked with Clifford La Fontaine. The team had little input into the building design, which was by Roche and Dinkeloo.

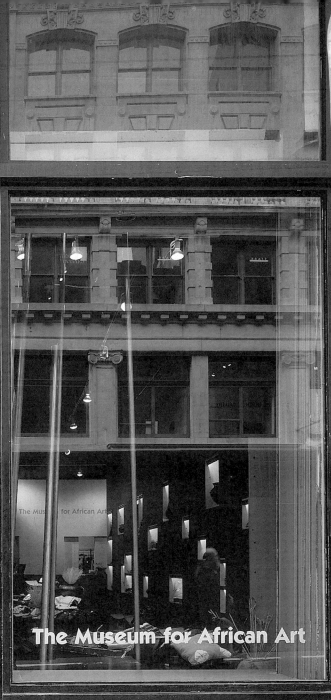

The Museum for African Art

Portrait of a Museum in Practice

Susan Vogel

LOOKING BACK ON THE MUSEUM FOR AFRICAN ART'S FIRST TEN YEARS has meant revisiting the Museum's restless experiment with exhibition techniques. Our attempts to make African art accessible have been highly esteemed. But this anniversary provides an occasion to address the abiding question of how faithful to African systems of presentation our exhibitions have been. It seems worthwhile to present to our audience the dilemmas and contradictions, the strategies and compromises, of contemporary museum practice—the ways in which that practice, and sometimes the institution of the museum itself, are profoundly at odds with traditional African presentations and definitions of art. Describing the process of bringing African artworks into the museum, and its limitations, also allows an indirect reflection on the broad issues inherent in all art-museum installations of all objects and artworks except those created with museums or galleries in mind.

Two factors have driven the Museum's concern with museum practices and installation theories. The first comes with the subject, African art—an art so manifestly not intended to be displayed in a museum that the objects themselves pose the question every time we try to install them. They have forced us to wrestle with the issue of how museums might better present the art of Africa, and what relationship this art should have to conventional museum presentation techniques. The second has been the high level of activity the Museum maintained from the

Fig. 1 (opposite page): Entrance to the Museum for African Art at 593 Broadway, Soho, 1993. The exterior of the Museum's current site was left unchanged because of city Landmarks Commission rules on alterations to historic buildings. Maya Lin's interior is a dramatic departure from the street view.

beginning—two or three major exhibitions every year. As we thought hard about how to install each one in the way most appropriate to it, and about the special issues and opportunities each installation offered, the repeated exercise of installing became a focus in itself. Alongside the African art that was the content, the museum setting that was the container also became a subject for display.

The first meeting of the group that would create the Museum for African Art (then named the Center for African Art) and constitute its first board occurred only weeks after the opening of the Rockefeller Wing at the Metropolitan Museum.[1] Having just finished working on the African part of that project, I naturally imagined exhibitions for the new Museum that were similar in philosophy and style to the African-art exhibitions I had curated at the Metropolitan—largely because no alternative models came to mind.[2] That approach seemed at the time slightly flawed but self-evident. As the world changed and I changed, though, I realized ideas were available to me that I had not permitted myself to think about before. Soon the old way came to seem a fairly narrow and constraining conception of African art and exhibiting, from which the Museum progressively departed as it felt its independence.

At the outset, the Museum's defining characteristics were partly conditioned by the Metropolitan, with its encyclopedic display of African art, its well-established library, and its lack of an active program of temporary African-art exhibitions. The new Museum would not form a collection or a library, and it would produce temporary exhibitions—loan shows that would be freed of the responsibility to teach the basics of African art, and of the obligation to be comprehensive. Against the fixed background of the Met, the Museum for African Art could play the chameleon, taking a different posture with each show. It could present single styles, ideas, or collections in depth; it could explore the nuances and byways, the overarching concepts and the untested hypotheses, of African art and theory.

I soon realized that these different explorations were best presented through different exhibition styles—even through different philosophies—rather than through a uniform institutional style. In fact it finally made sense to adopt styles that were generally considered mutually exclusive within the same museum—styles that crossed genres, trespassing into the realms of anthropology museums, outdated museums, and even theater. But that comes later in the story.

Because its exhibitions have been temporary, the Museum for African Art as an institution has been characterized by no single exhibition. Rather, the ability to approach African art from many different directions has become its greatest attraction and defining attribute. Almost from the outset, the Museum's posture departed radically from the Metropolitan's by denying the apparent authority, inevitability, and unanimity of the museological voice. By virtue of its nature and size, the Metropolitan was inflexible, and committed to the recitation of an accepted master narrative of world art history. The Museum for African Art, on the other hand, recognized from the outset that it was impossible to reduce African art to a single point of view. Africa and its art, history, and peoples were too inherently varied, too contested, and had infiltrated too many parts of the American and modernist stories to be described in any single way (fig. 2–3).

This determining reality became the subject for "Perspectives: Angles on African Art," an exhibition planned before the Museum opened and presented three years later, in 1987. The show's subject was the many ways African art is regarded in the West, and the different roles it plays. This was the Museum's first exhibition to

MAUREEN HEALY: I think museums are, for so many people, a terrifying experience. You really wonder why they subject themselves to it: walk up those steps, feel like [an outsider], walk into the room, overhear a docent who of course sounds like she knows everything, have everybody else in the room seem to have the mask of knowledgeability and . . . the same kind of laugh, like a we're-in-the-know kind of giggle. There must be something inside of a lot of people that feels very inferior when they get through that.

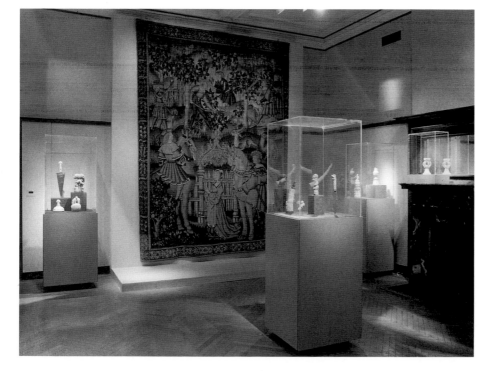

Fig. 2: Installation of "Africa and the Renaissance," Center for African Art, 1988, showing small Sapi-Portugese ivory objects and a late–fifteenth-century Franco-Flemish tapestry from the series "The Hunt of the Unicorn." This exhibition was one of the Center's most beautiful and most surprising. To cover blocks, decks, and the gallery walls, we used hand-dyed damask from Cote d'Ivoire, where such fabrics are widely used for garments. It introduced visitors to 15th and 16th century ivories made by African artists for European courts.

focus on the audience and its perceptions of African art rather than on the African art itself. Ten "curators" ranging from David Rockefeller to Romare Bearden were asked to select works for the exhibition and to discuss their personal views of their selection in the labels and catalogue. The New York Times reviewer remarked with relief that the labels "lacked the single authoritative voice" associated with museum explanations, and that this "encourag[ed] viewers to slow down, look more carefully and think for themselves" (Smith 1987). "Perspectives" combined exceptionally varied sculptures of stunning quality with thought-provoking texts. The catalogue included our first attempts to make the exhibition process more transparent: it pointed out that the authenticity of one object in the exhibition was in doubt, and described the compromises that had been necessary to include a selection and comments from an artist living in Africa.[3] The rich variety of points of view articulated by the ten participants, many of whom were public figures, made this book a provocative source of raw data.

"Africa Explores: Twentieth Century African Art," 1991, was a later exhibition that used a multitude of voices to give the audience a sense of the complexity of contemporary culture in Africa. Breaking with art-historical tradition, "Africa

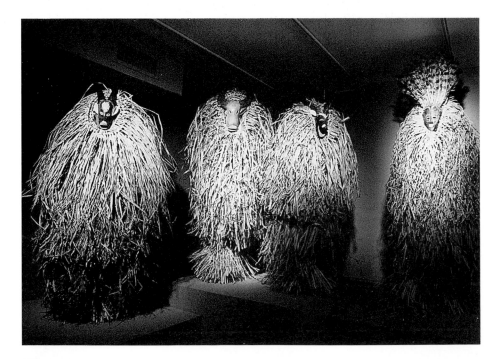

Fig. 3: "Arts of the Guro of Ivory Coast," organized by the Rietberg Museum, Zurich, Center for African Art, 1985. This display of four Guro masks, complete with raffia costumes, departs from the Museum of Primitive Art paradigm of display, as raffia was previously considered too "anthropological" for an art museum installation.

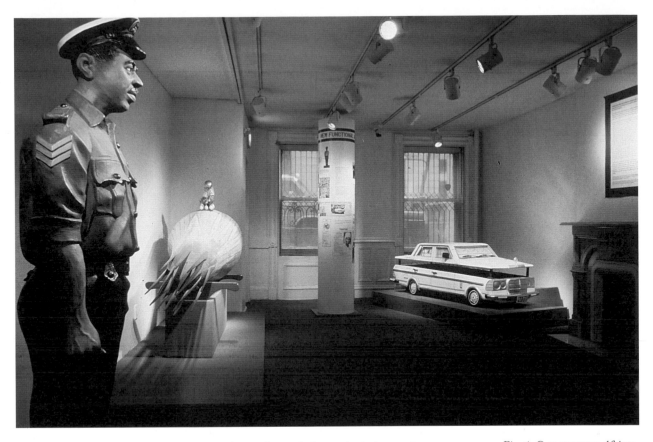

Explores" showed in one exhibition art from all social classes, insisting on its interconnectedness. But the installation also had to express the real differences among the voices presented: five different wall colors were used to suggest walls in the various African environments from which the works had come, and to signal to visitors that this was not just some more contemporary art in SoHo.

Wall texts and label copy were produced in the form of original documents presented on a tall round kiosk in each gallery (fig. 4). We chose the kiosk because, like a community bulletin board, it carried connotations of popular notices and posters, with their transience and informality, and implied that the information contained there might constantly change, and that it came from many different people and could not be definitive. We hoped that visitors would "read" these qualities into the messages without focusing particularly on the kiosk itself. Alongside all the other voices on each kiosk, the Museum's voice appeared only in the heading and in a short, general text. Among the items posted were statements

Fig. 4: Contemporary African art in the exhibition "Africa Explores," Center for African Art, 1991. Many different documents were presented on kiosks to convey the idea that information about contemporary African art might come from many different people and be constantly in flux, representing no authoritative "truth." The Museum's text appeared on the kiosk alongside texts from other sources.

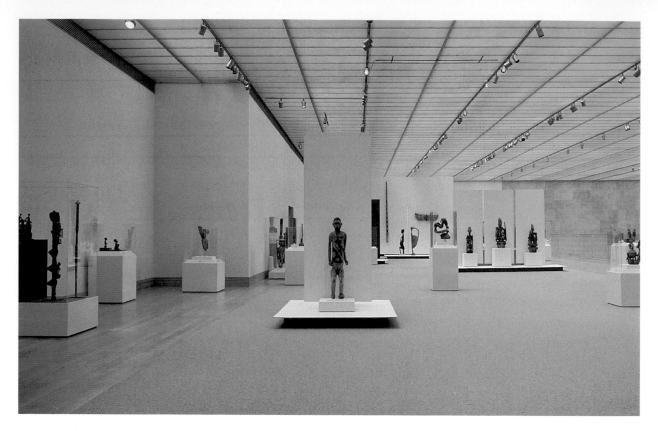

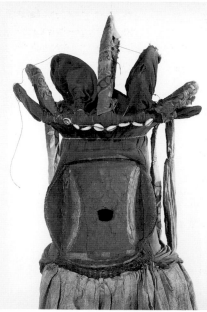

Fig. 5 (left): Helmet and costume, Teke, Congo, displayed in "African Masterpieces from the Musée de l'Homme," 1984. This intriguingly awkward sculpture was exhibited to expand the public conception of African art to include unconventional forms, materials, and techniques.

Fig. 6 (above): "For Spirits and Kings: The Paul and Ruth Tishman Collection," Metropolitan Museum of Art, 1981. The high ceilings, vast scale, and natural light nullified the human scale and sculptural intensity of the African objects. Slanting decks resulted in oversize vitrines that kept the visitor from getting close to the objects.

and letters from the artists, quotes from scholars and critics, photographs, clippings from African newspapers, and even a cartoon. Because the conversation on contemporary African art is so new, and there is still so little consensus on major questions, this seemed a good way to present contradictory information and to convey the statements' contingent nature.

THE ATTEMPT TO UNDERSTAND THE CONTESTED AND MULTIFARIOUS CHARACTER of what we called "African art" was built into the Museum's founding, but wasn't mentioned in its 1982 charter of incorporation. This document broadly staked out the Museum's goals, and described what its activities would be:

> The Center for African Art has been formed to increase the understanding and appreciation of Africa's ancient cultures. It will present three art exhibitions each year, publish catalogues and educational brochures to accompany the exhibitions, and sponsor related lecture and film programs. The exhibitions will be broad in scope, educational in subject, and of the highest aesthetic quality. The Center is founded in the belief that traditional African art, an eloquent testimony to the richness of Black culture, is one of mankind's highest achievements.

At the time, there was a sense that the struggle to create a recognition of African art's status as art had been won—but the charter could not dispense with asserting its value again. Written more than two years after the Wing opened, the introduction to the catalogue for the Museum's first show was still dealing with this issue, observing that the term "ethnographic specimen" covered a shrinking group of objects, and that it was now possible to select exhibition objects "less defensively than in the past"—that African objects once thought "rough and horrifying" could now be appreciated as artworks (Vogel 1984:11). Freed from the necessity to create an exhibition that would be neutral and enduring (as in the Rockefeller Wing), no longer trying to fit African art into the history of world art, and endowed with an audience that didn't need to be convinced of African art's worth, we selected new kinds of objects for the exhibition. Most conspicuous among these former "ethnographic specimens" was a ten-foot-high Teke (Congo) helmet with costume— a blank expanse of cloth topped by an eerie head made of what may have been mud, its only feature, a hole, suggesting both single eye and gaping mouth.

MICHAEL BRENSON: It's a question of how much I would trust the information in a temporary exhibition. And there I know I tend to trust more the stone images than I do the wood images . . . trust that there is an essential truth that I can pick up from what I'm looking at, which may be just part of a much larger context but [is] nevertheless something that I could hold on to and that I think I could hold on to legitimately. When I see an African sculpture I am more dependent on the context in which I see it, but I have less faith in that context. As a result, I have less trust in myself.

ARTHUR DANTO: You go in and [the museum] has a case full of things, you have a bowl of beans, my god they've got knives, they've got forks! That's really sort of amazing—that being in a museum might make something somehow an object.

The presence of this provocative object expressed an aspect of the Museum's agenda and philosophy: the presentation of African art and culture in all their diversity and difference. More visible, though, was the conflicting desire to present Africa and African art as accessible and admirable. In truth, seduction and enchantment have been immediate goals of all the Museum's exhibitions, in the belief that sheer pleasure—aesthetic, intellectual, and sensuous—would lead to success in the ultimate goal: increasing admiration and understanding of African art and the people who have made it. The arresting presence of works of high aesthetic quality, we believed, would lead visitors to want to know more about them and the civilizations that produced them. As Robert Goldwater, director of the Museum of Primitive Art, had put it, "Appreciation is one path to understanding" (Redford et al. 1959:8–9).[4] Though we discreetly supplied copious information about the works of art, they were there to be enjoyed in themselves.

The small size and intimate scale of most African objects had been a problem in the installation of the Rockefeller Wing, where much of the ceiling was twenty-six feet high, and the spaces were vast and could not be partitioned (for security and climate-control reasons).[5] The intensity of many African works was diluted in that expanse, and it was hard to give visitors close contact with them (fig. 6). Almost all African objects are made to the measure of the human body, and many were meant to be in contact with the body: masks, stools, drums, staffs, doors, and, in Africa, even figure sculptures are touched, worn, held, or carried at some point in their use. Traditional African buildings also tend to be small and human in scale. The domestic proportions of the buildings the Museum occupied on 68th Street were a great improvement, then.[6]

Another display problem that had been insoluble at the Metropolitan was easily dealt with in the smaller rooms on 68th Street, where we avoided using wall cases as much as possible, showing almost all the works in free-standing cases in the round. (In the Metropolitan's large galleries, this design would have created an endless forest of cases). The exhibition designer Maureen Healy was asked to design reusable display cases and vitrines that would put the audience close to the objects. They had flat decks, invisible hardware, and were smaller than usual, permitting us to isolate many sculptures. Slope-edged decks had come into general favor—and were used throughout the Rockefeller Wing—partly because the angled border

104

provided a convenient place for labels that could be read from wheelchairs. They had the defects of physically distancing the viewer from the object, and of creating a visual border/barrier between them. Labels outside the cases removed this barrier and could be put at a height for all audiences.

TEN YEARS AT THE METROPOLITAN HAD GIVEN ME A CLEAR SENSE of how difficult it was for many people—including confident, sophisticated people who saw African art as art—to really look at and react to African art objects. At Acquisition Committee meetings, trustees and senior curators had often seemed to feel that they could not trust their taste or knowledge when it came to looking at the work I showed them. Their eyes went blank. They seemed bedeviled by doubts of the most basic sort—is this old? Is this a good one? Is it supposed to look uneven/frightening/sexual, etc.? Am I supposed to like it? It was clear that many viewers of African art had to be reassured, given license to feel their own responses, before there could be any possibility of their absorption in the work.

The strategy the Museum adopted was obvious: as far as possible, we associated African art with a language of reassurance and validation. The elegant townhouse setting, we hoped, would also do its part to answer the nagging questions. The first exhibition was of "masterpieces"—so labeled at the door—from the Musée de l'Homme, France's national museum of ethnography, where Picasso's famous "discovery" of African art had taken place. The exhibition opened the day before the Museum of Modern Art's heavily attended and publicized "'Primitivism'" show—not by coincidence. The constellation of Western artists' names in that exhibition, and the beautiful galleries we had created, would help the visitor relax, we thought, and take in what were genuinely some of the most riveting and beautiful African sculptures anywhere. These sculptures were paying their first visit to America in fifty years, and were unlikely to be back for a long time (fig 7).

Though innovative installation was not the intention, the show looked unlike any that had been done before in the field: historical and stylistic references were to the nineteenth century rather than to modernism. The installation appeared more conservative than any that had been presented at the Museum of Primitive Art, and old-fashioned even compared to Stieglitz's display of 1914. Partly for practical reasons but mainly because it served a purpose, we preserved the feel of the

themselves, "Well, this is this installation, but it could be any other."

ROBERT FARRIS THOMPSON: I would suggest that as we do this we try to avoid the problem of excess consciousness of self. . . . You can become so self-conscious about cultural boundaries that you get paralyzed. I would suggest, as a model, the late and great John Coltrane. When he picked up the sax, he did not worry that this is a Belgian, white instrument; he simply turned it into an Afro-Asian bassoon.

FRED WILSON: I would use the word "ownership". . . . While we go to [museums] to experience something, it's not a something that we particularly feel that we have any intrinsic involvement with [or] ownership over. It's supposed to be a separate experience, even though it may have the most to do with you.

CAROL DUNCAN: Some individuals may use ritual sites more knowledgeably than others—they may be more educationally prepared to respond to their symbolic cues.

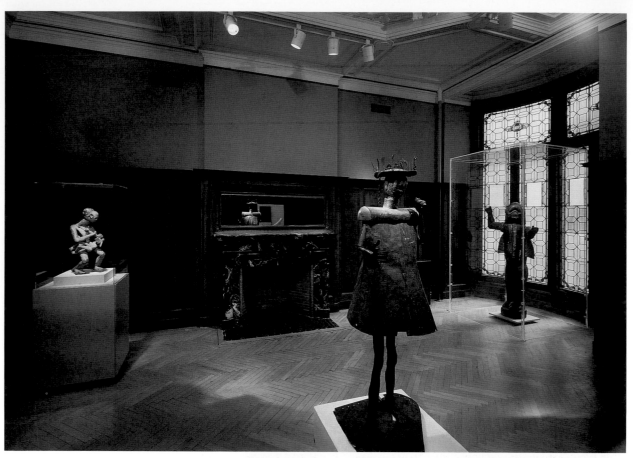

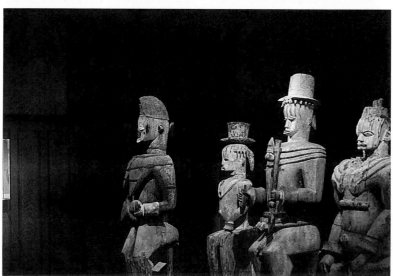

Fig. 7 (above): "African Masterpieces from the Musée de l'Homme," Center for African Art, 1984. Featuring several famous African objects from the Musée de L'Homme's collection, including the Fon "God of War" and "King Behanzin as a Shark," the inaugural exhibition was installed in a room that preserved a domestic atmosphere, with an intimate scale and nineteenth-century decorations.

Fig. 8 (right): "Sets, Series, and Ensembles in African Art," Center for African Art, 1985. Five monumental Urhobo figures were exhibited in a rather small gallery, a setting evocative of the small shrine rooms in which they were kept in Nigeria.

townhouse—the sense that this was a visit to an elegant private residence.[7] The buildings' fireplaces, paneling, plasterwork on the ceilings, and leaded windows remained, and the walls were painted a different shade in each room—as they might be in a home. Plexiglas cases were designed for the mantels, allowing us to display objects on them. Labels would have shattered the fiction of a gracious domestic interior; though long, they were made inconspicuous, printed on paper that matched the walls. While all the colors were similar in value, the warm colors of the walls separated the architecture from the cool blue-gray of the free-standing cases that rose from the floors. The African art seemed at home in this environment in part because of the human scale of the rooms, in part because it too seemed old, and in part because of the natural obviousness of the approach. Faint echoes of other private homes converted into museums only served to make the atmosphere vaguely familiar, reassuring—and prestigious.

After this most legitimating and aesthetic of beginnings, the Museum presented two exhibitions within a year and a half that were fairly anthropological in approach. Both dealt with the art of single ethnic groups, and both were organized by other museums: "Igbo Arts: Community and Cosmos" by the Museum of Cultural History, UCLA; and "Arts of the Guro of Ivory Coast" by the Reitberg Museum, Zurich.[8] With relish, we installed something that had always been taboo in art exhibitions: costumed mannequins. Raffia! Set on platforms in both exhibitions, these figures suggested that costume and mask should be viewed as a single aesthetic statement. Context and placement prevented the mannequins from being seen as remnants of the dowdy ethnographic installations that had been left behind when African art moved out of the natural history museum.

The Museum's own second exhibition, "Sets, Series and Ensembles in African Art," curated by George Preston in 1985, proposed a new way of thinking about the old problem of contextualizing African art: it considered groups of objects that would have appeared together in Africa, or that formed a single conceptual category there (fig 8). In this show, these groups would create a context of their own. One section evoked the original setting by using the intimate scale of our building: five huge carved Urhobo figures with jutting, aggressive forms were lined up across our largest gallery (a former dining room, it was only about twenty feet square), confronting the

IVAN KARP: The question is, how do you deal with context? How do you get away from the diorama/realist representation of context, and how do you do it in a way that surrounds, that is experiential, rather than referential, which is what the diorama is, unknowingly? . . . Figure out how to strike a balance between the objects and the concepts, not in the formulation of a grant, or a catalogue, but in the installation of a designed exhibit. And . . . experiment with the audience's experience.

visitor as they had in the small shrine rooms they were made to inhabit in Nigeria. Though these were seated figures, two were nearly seven feet high. In the narrow space, they were imposing and a little intimidating to the museum visitor, who could appreciate the awe they had inspired in Urhobo visitors to the shrines.

I now realize that this kind of evocative installation approach, which Douglas Newton has called "osmotic," had been used by Rene d'Harnoncourt in the 1940s and '50s (and later by Newton too) in the exhibitions of pre-Columbian and Oceanic art that he designed at the Museum of Modern Art. "The installation, including the colors used and the lighting, conveyed subliminally the atmospheres and conditions" without any "literal replications of any physical conditions . . . in an attempt to foster an intuitive understanding of the works of art rather than literal explanations. Explanatory devices, it was felt, could be more properly handled by the ethnographic museums" (Newton 1978:46). In the Museum for African Art's practice, the evocation of a possible original setting has been supplemented by field photographs and text discreetly available in the room. And never have we attempted to create a particular atmosphere throughout an entire exhibition, as d'Harnoncourt apparently did.

The exhibition "Wild Spirits Strong Medicine: African Art and the Wilderness" contained two evocations of another sort.[9] In one, a host of large patterned Bwa masks from Burkina Faso were installed, with costumes, in positions re-creating a field photograph of mask dancers seated resting on the ground. The intention was to show how the colors and textures of the costumes, and the massed patterns of the masks, formed a single aesthetic statement, richer than its isolated parts (fig. 9–10).

The costumes concealed the dancers' bodies except for their hands and feet. We didn't want to be too literal in the re-creation, but also didn't want the distraction of mannequin hands and feet in another style and material—another artist's vision. We settled on life casts, which produced hands and feet that just looked like hands and feet, uninteresting and unremarkable —exactly what we wanted. To avoid the naturalism that would also have been distracting, the casts were painted the same deep indigo as the platforms on which they were installed. Only a few of the figures actually had cast hands and feet—something had to be left for the imagination of the onlookers to fill in.

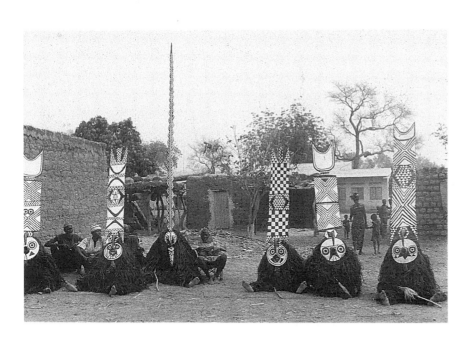

Fig. 9 (left): Bwa plank masks and a serpent mask resting during a ceremony in the village of Boni, Burkina Faso, 1985. This photo was the basis for the installation of Bwa masks in the Center's 1989 exhibition "Wild Spirits Strong Medicine." It suggests how a variety of patterns can play off each other in such an ensemble.

Fig. 10 (below): Display of seven Bwa masks in "Wild Spirits Strong Medicine," Center for African Art, 1989. The installation of the costumed masks shows the troupe resting during a performance. The mannequins' hands and feet were cast from life and painted dark indigo to match the background (see left figure).

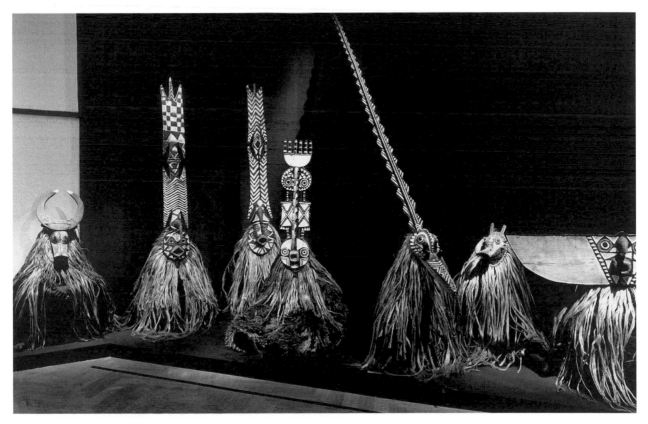

"SETS, SERIES AND ENSEMBLES" HAD addressed African classification systems, but had focused on object types that also fell into the Western classifications of art—excluding, in other words, apparently nonaesthetic, unelaborated items such as the leaves, offerings, vessels, costumes, instruments, stones, and parts of birds and animals that in Africa are often also among the essential elements in meaningful groups of objects (but that in Western collections are scarce outside natural history museums). This early exhibition underscored the inherent conflict between the museum's advocacy role—its emphasis on the aesthetic, self-evidently admirable dimensions of African objects—and its educational role.

The conflict belonged to my own—and other researchers'—dual experience of African art. In the West we saw and handled beautiful objects in museum vitrines and storerooms, and in private collections; in Africa we saw heaps of dusty sculptures in the stores of urban art dealers, or, more memorably, we saw few, rare, dimly lit, often imperfect objects in the villages, where they were immersed in other things—the leaves, pots, bottles, sacrifices, words, and lives—that we could never carry into the art museum. The difference was total, the contrast stark. The Museum of Primitive Art had been run by people who had never been to Africa, and who were therefore aware of this contradiction only intellectually. (Newton had done fieldwork in New Guinea, and his New Guinea exhibitions had more grit to their installations.[10]) Perhaps the Museum's pristine modernism, and that of other, earlier exhibitions, would have been impossible to sustain otherwise.

The African settings of African art begged to be brought to the Western museum visitor, as if seeing them would lend understanding. But in the "produced," perfect, highly visual museum, the uninitiated visitor would likely see them as dirty, incoherent, and redolent of material poverty. Though we believed they manifested an intellectual and spiritual richness, we didn't know how to translate it. For Western audiences, the artwork is distinguishable from the ethnographic object by its ability to evoke meanings and feelings across time and cultural boundaries, whereas the unelaborated bundle of leaves, unaccompanied by prose, does so only minimally. This seems to be changing slowly, as Western audiences are becoming more prepared to concede that African cultures have complex abstract belief systems. And contemporary Western artists have again led the way to new ways of seeing by creating works that resemble ethnographic items: the purely visual interest of, say, a

well-tied bundle of leaves has increased. In the right context, it can now have the aura of an art object.

Museums can clearly confer this aura on the most banal objects simply by putting them in the galleries with the customary museum trappings of reverence and value. "ART/artifact: African Art in Anthropology Collections," 1988, the Museum for African Art's best-known exhibition, addressed the issue of boundaries and definitions that surround the notion of "art" (fig. 11). It suggested that, like the bundle of leaves, many "ethnographic" objects might now be regarded as art. The exhibition also exhibited installation practices themselves as artifacts of contemporary culture. It exposed the phenomenon of the museum aura by presenting similar objects in different kinds of installations, revealing how important the setting of the object was in shaping the visitor's perception—sometimes more important than the appearance of the object itself.[11]

"ART/artifact" examined how the whole social, cultural, informational, and material environment of African art influences the way it is seen and what it literally looks like. If "clothes make the man," then "installation makes the African artwork." (Everything is an artifact—nothing is needed to "make" an object an artifact). The literal and metaphoric ownership of the objects, and their insertion into one of many Western categories, determine their present identities, in ways that can be more powerful than the identities given them by their original makers. This exhibition, like "Perspectives," was one of several exhibitions at the Museum arguing that where you stand influences what you see.

The same message was given an extreme, literal expression in "Closeup: Lessons in the Art of Seeing African Sculpture," 1990, which addressed the individual viewer (figs. 13–17).[12] The exhibition began with a wall text (repeated as the foreword of the catalogue): "Museums generally assume that the audience knows how to look, and proceed directly to an explanation of the work. It seemed worthwhile to suspend the explanations for the moment, and to take a close look at looking." Going against most museum practice, the exhibition contained virtually no other text labels beyond minimal identifications and a small information sheet in the corner of each gallery. In an effort to produce a completely visual show, the "labels" on the cases were uncaptioned detail photographs of the objects in the vitrines, a sort of "did you notice this?" visual suggestion. The rooms were arranged according to

CHRIS MÜLLER: It's kind of a semiotics of museum practice . . . it leads you down the garden path. . . . At some point you realize that you're being lied to.

FRED WILSON: I was also thinking that we have to be concerned with the way we use design systems and technology to try to create symbolism. Often when lighting, sound, and video are used to simulate actual experience in the field, in Africa, what is triggered in our senses, our brain, is our memory of "museum" rather than a greater understanding of material and display. Our experience of American technology is reinforced rather than getting closer to a real experience of Africa. . . . We must either make the designed space and technology clearly apparent so the viewer is aware of their manipulation, their "Westernness," or we must thoroughly understand how the designed space creates meaning so that when it is used it has the desired effect.

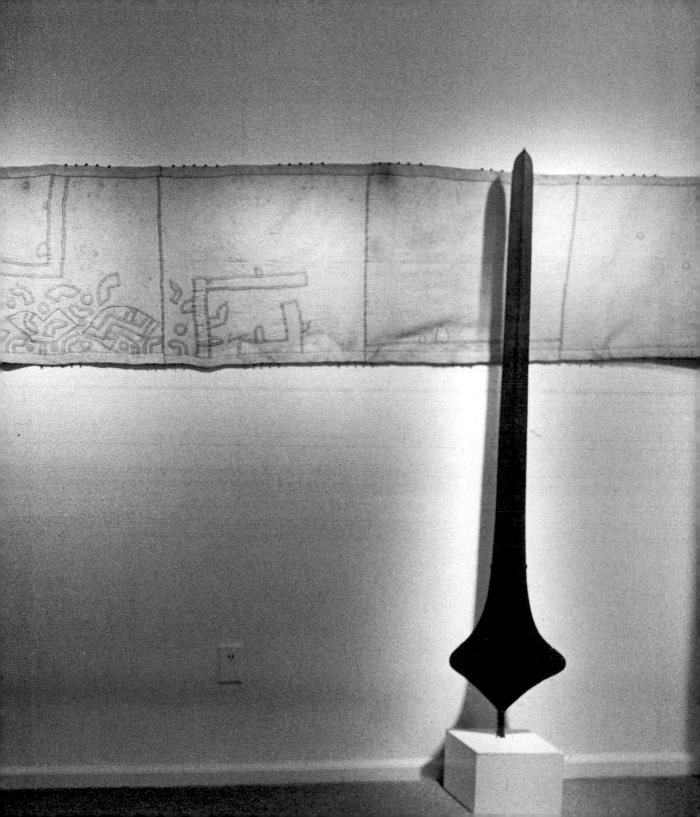

Fig. 11 (previous page): "ART/artifact," Center for African Art, 1988. This particular mode of display presents African objects that might or might not be considered "art" in a style that confers aesthetic value on them and suggests they will reward intense scrutiny.

MAUREEN HEALY: Comfort is almost too mundane to talk about, but I think [museums] insult the audience. I think a lot of the connections with the objects, people are capable of [making themselves]: they don't need incredible instructions from authorities. What they need is a chair to sit down in, and what they need is a bench that's big enough to change the baby if the baby gets wet, places that are quiet enough but not so silent that you can't laugh or make a comment. That kind of physical comfort will take the viewer so far along.

visual and formal characteristics of the sculptures (such as "Voids" and "Scale"), with large detail photographs under the room titles providing an instant idea of what the titles meant.

In each gallery, one sculpture, isolated against photographers' background paper, could be viewed through two or three eyepieces fixed at set heights and angles. These weren't lenses, simply devices for showing the audience a particular view.[13] Commentary next to the eyepieces compared the different views, and discussed what was revealed and what was hidden from each viewpoint. Here, where you stood obviously as well as metaphorically controlled what you saw. The show also returned to the Museum's ongoing program of trying to provide a range of different viewpoints. "Closeup" explicitly mapped out the Museum for African Art's philosophy on the gallery floor.

THE PATH OF PRESENTING VIEWPOINTS that were not my own, and practices not usually accommodated in any sort of museum, eventually led to an exhibition that in many ways went to the limits of art-museum practice. Installing "Face of the Gods: Art and Altars of Africa and the African Americas" in 1993 forced us to deal with every inch of contested museum terrain, challenging accepted notions (including our own!) of artists, authenticity, taste, devotion, and the boundaries among genres of display—and between display and the creation of works of art.[14]

Curator Robert Farris Thompson's thesis in the exhibition was that altars were an art form in themselves, and were to be regarded as single works, though they might include hundreds of individual sculptures and might be assembled over time by a number of people not necessarily working together. Another of Thompson's premises was that we would exhibit consecrated, functioning altars made in the museum by priests and altar artists, and that they would be the objects of devotions. In traditional museum practice, religious objects are commonly exhibited as art, somehow drained of their spiritual power—even when they pertain to the Christian faith of a great many museum visitors. I wondered if it was respectful to install functioning altars to be looked at in a public museum, where many visitors wouldn't share the faith that informed them. Did they require certain postures of respect that the audience would inevitably violate? The altars in "Face of the Gods" would ordinarily have been constructed in homes or places of worship closed to the lay

public or the curious. What were the implications of exhibiting them in a museum, and of exposing them to the critiques of the art press?

My scruples were answered by the religious practitioners who made the altars we showed in the Museum, and who were pleased with the opportunity for public recognition of themselves and of their faiths that Thompson's exhibition offered. So far from feeling it was disrespectful to exhibit their altars, they consecrated their work, making it sacred. Subsequently, these altars became the focus of devotions performed by the public. The altar created by Felipe García Villamil, for example, had several special requirements, including being fed each week with rum. While the exhibition was in New York, an assistant of Felipe's came each week to make the offering, but once the exhibition traveled the altar had to be fed by the registrars of the museums on the tour. What was the appropriate attitude of a nonbeliever toward this request? And what did it say about the African sculptures in the exhibition, which had once had similar requirements?

Only a few complete and movable altars could be brought into the Museum; the others we had to produce somehow. We resorted to four kinds of installation techniques from different kinds of museums—techniques not usually found in art museums. Easiest were the nineteenth-century African sculptures, which we installed in our usual fashion, isolated in free-standing Plexi-topped pedestals. Beginning at the Museum of Primitive Art, and increasing over time as my own work advanced, I had come to see the purity of the aestheticizing museum presentation of African art as increasingly vitiated, sterile, and false. Here, alongside altars that maintained religious functions, the beautiful African sculptures looked faintly lifeless and a little dull to me.

Some altars, such as the Nigerian Yoruba Shango altar, we constructed from photographs of altars in use, mixing authentic objects with objects and constructions we produced. These reconstructions using traditional art objects followed the diorama tradition of the natural history museums, a tradition very occasionally employed in art museums—especially for African art—to convey information and facilitate looking at sculptures. "Face of the Gods" used it with a difference: the reconstructions were the exhibit, not just the frame for works of art. Exhibition designer Chris Müller used his background in theater design to locate scene painters, set builders, fabric drapers, specialized lighting people, and, most exotic of all,

IVAN KARP: I'd ask the question: to what degree does all the sophistication and planning and scholarship that goes into [an exhibition] run up against the wall of representations that people bring into the museums? Remember . . . the audience [is] not coming innocently into the museum. . . . They already have notions about Africa. So the question is: can you avoid this?

MAYA LIN: You could put text on the floor . . . so the text no longer becomes text; text becomes spatial. Once you put words on floors it's a very different read, and it can walk you through a space. It's much more spatial than you would normally think of text being used.

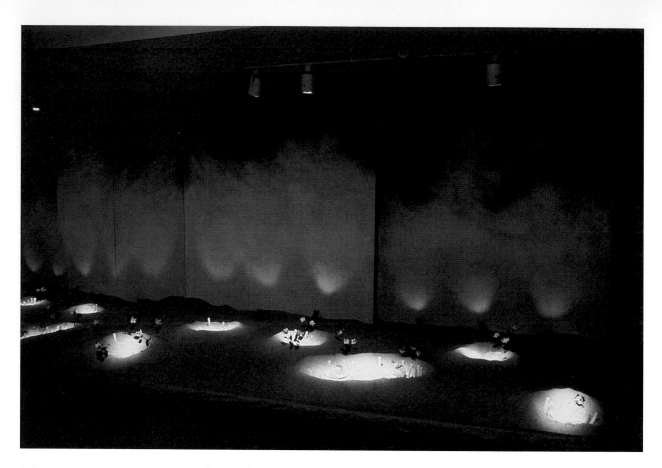

Fig. 12: The "Ultimate Altar: the Atlantic Ocean on New Year's Eve," in the exhibition "Face of the Gods," Museum for African Art, 1993. Each year, thousands of Brazilians make altars on the beach to Yemanja, Brazilian-Yoruba goddess of waters. In this installation, intensely focused light plays on grapes, roses, and unlit candles in hollows in the sand.

professional shoppers to find the multitude of objects and textiles needed to "dress" the altars properly. Müller's team hung, stapled, glued, and painted the parts together to look as they did in the photographs.

Other reconstructions, such as Balbino de Paula's great Obatala and Omo-Olu altars, were created by the same artist-priests who had made the untransportable, or now destroyed, originals in the photographs. Artists invited from Brazil, Cuba, and parts of the U.S. came to build their altars in the Museum, assisted by scene painters, drapers, and carpenters. All of these altars were consecrated when they were finished, and their authors considered them "authentic." Still others had to be made entirely by the museum's crew with no input from priests. Where do the art historian and connoisseur's definitions of authenticity fit in this thicket of variations?

As the culminating altar, we wanted to represent the beach at Rio de Janeiro at midnight on New Year's Eve, when offerings transform the entire strand into a vast

altar to Yemanja, Brazilian Yoruba goddess of the sea (fig.12). No "objects" were involved, only flowers, candles, perhaps some food offerings, and champagne. We succeeded in creating a surprisingly beautiful and moving environment. But what exactly was it? Less a diorama than almost a work of art in its own right—but who was the artist? Darrel Maloney, who designed and lit it? The Brazilian Yoruba who collectively over time "designed" the original? And was it really a work of art after all, when its purpose was fundamentally to teach and inform—to lead the onlooker to something beyond itself? Most crucially: did it belong in a museum of African art?

"Face of the Gods" illuminated limitations in museum practice of the most compelling kind. (The material limitations of museology—in funds, space, time, etc.—are ever present, but banal and uninteresting.) We believe we didn't exceed propriety, but the exhibition did bring us close to the edge of what art museums generally imagine they can do. I became acutely aware that art museums can do more, but only if they succeed in bringing their audience with them. Here, too obvious or inept a set of reconstructions would have lost the audience, failed to interest and convince them, ultimately failed to transport, enchant, and instruct as art museums must.

"Exhibition-*ism*"

I have begun to wonder how useful overt lies might be in a museum exhibition:[15] a gallery in which the contents clearly contradicted statements boldly screened on the wall would provoke the visitor to look closely and to form his or her own ideas. (Just as the personal, opinionated viewpoints expressed in the "Perspectives" labels had provoked the audience to agree—or disagree.) This and other ideas about installation provide the method of "Exhibition-*ism*," a show in which a paradoxical presentation, even more than an interrogative one, is intended to heighten awareness of other museological deceptions, concealments, and pretensions.

The challenge is to present audiences with enough clear information so that they can emerge stimulated rather than confused or annoyed. Irony and humor, though often present in individual works of art, are encountered so seldom in museums that there is a great risk they won't be recognized for what they are. But they are useful tools for introducing certain ideas—the raucous reality behind the pompous museum facade, the practical obstacles that inhibit installation possibilities,

IVAN KARP: What about voices? I mean what about actual voices, English-speaking voices, coming at you from the air? [It's] cheap. Easy to do. Horrifying to some museum curators. . . . You can't ignore it. [It] breaks up the stream of contemplation. Think of experience not in a benign way but in a conflictual, confrontational way. That is, you're having one kind of experience—"I'm developing a very nice relationship with this object"—and then you see what the museum can do to destroy that relationship for the moment. It seems to me that this is the place where you should be taking all your risks. You will take the risk of having some people leave the museum in a rage. And you can ask, "Why are you leaving in a rage?" One of the ways to not have them leave in a rage is to state your intentions at the beginning.

117

Figs. 13–17: "Closeup," Center for African Art, 1990. This exhibition heightened viewers' visual access by presenting African objects with little or no explanatory text and encouraging them to look at the sculptures from several different vantage points. It accomplished this through lighting, special viewing devices, and black-and-white photographs displayed next to the objects, which served as visual labels. This made literal the museum's philosophy—that what you see depends on where you stand. The photographs were taken by Jerry L. Thompson, co-author of the accompanying exhibition catalogue.

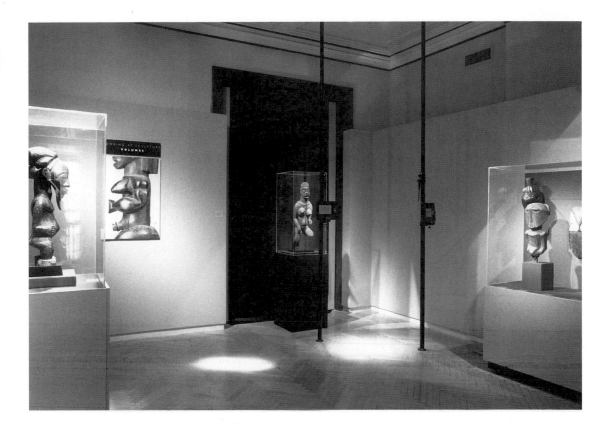

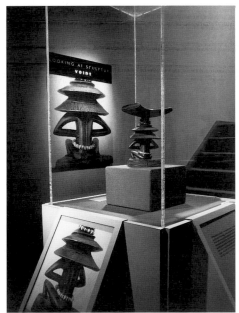

MAYA LIN: What would you like people to leave with when they come to the Museum? When they leave, what would you like them to take away?

TAJUDEEN RAJI: Maya made a good point about the entrance of the museum: maybe one can tell a story that starts from the entrance of the museum and ends in the last gallery. At the same time, would it be possible to [show that] where you enter, you close out the outside world—you are in a different place, this is where you are? And when you get out, it should be an experience you want to tell others about, or you want to return to.

the futility of attempting to recreate an "authentic " African experience, and the impossibility of achieving a definitive understanding or experience of anything so complex as a work of art, especially one from another culture.

"Exhibition-*ism*," still in the planning stages at this writing, will examine four specific areas in which Western museum practice contradicts the ways art is meant to be apprehended in Africa (and in many other cultures throughout history). The first gallery, for example, will have the wall title "Museums Are Silent Places for Looking," reflecting almost the defining characteristic of the museum—a place for intense, exalted looking, to the exclusion of the other senses. In Africa, however, traditional art is usually part of a constellation of sensory stimuli, nearly always including sounds (both words and music), motion, and often smells and tastes. (Celebrations and sacrifices attending the appearance of art in Africa usually involve eating better food, or more food than usual, which is part of their satisfaction.)

Despite its label, this gallery will be filled with sounds. Besides works of art in vitrines, it will contain video monitors showing different contexts for viewing artwork in Africa: the carving of a mask, the wearing and dancing of a mask, and a figure installed in a shrine. The monitors will play one after the other, each producing sounds in turn, and suggesting to visitors that they move around the room, like spectators at some African dance performances. At this writing, we are thinking about providing a dish of candy in the room so the audience can "eat." This device, however, underscores the impossibility of translating experiences across cultures, for the significance of feasting or eating sacrificial meat in Africa is of course totally different from the trivial invitation to an American to take a piece of candy. Only the engagement of another sense is analogous.

The second gallery will be titled "Museums Provide Access to Art" and will deal with the numerous barriers that museums throw up between the viewer and the object. We may place a guard at the door who will ask to see an admissions button, and who will watch people in the room. The cases will have the usual Plexiglas and perhaps a rope and stanchion as well. In Africa, the experience of art is often communal—whole groups of people are present when works of art are exposed or performed. A text label will make that point, and may encourage visitors to talk to each other or to the guard.

In the West, the often sensuous experience of art is purely private and internal. Perhaps because of this, people often feel uncomfortable watched by guards and others in museums. We will build three or four small booths, each containing a single object of exceptional interest that in Africa would customarily be seen alone. Visitors will be able to enter these booths and sit alone with the work, out of sight of the public and the guards. (Unfortunately, the sculptures will have to be alarmed, secured, and behind Plexiglas). The visitor may be able to operate a turntable and choose preferred viewing angles.

Under the title "What the Museum Shows," the third gallery will hold a ring of vitrines facing outward and containing objects exhibited and labeled in the usual fashion. The area inside the ring, titled "What the Museum Knows" (the label perhaps written on the floor, an unusual site for text in museum space), will show the backs of the artworks, mainly sculptures such as face masks, not meant to be seen in the round. Mounts, blocks, lenders' tags, identification stickers, loan requests and loan forms, condition reports, and other internal documents will appear on the rear of the cases. People will be able to see the black paper used to cover the eyeholes of some masks, and perhaps some unconcealed conservation work. One pedestal may be left open to show the sandbags placed in the bottom to stabilize it. The space will present the utilitarian side of the museum operation, which is usually carefully hidden from the public—as it is in most working businesses, from restaurants to department stores. In Africa too, the presentation of works of art is carefully controlled. Masks, for example, aren't normally seen except when they are worn; shrines and other displays are often kept behind curtains, which are opened at the proper moments. A certain formality often attends the viewing of important objects.

The fourth gallery, titled "Art in Museums Never Changes," will address the museum's treatment of time. The museum is dedicated to arresting not only the appearance of change, through the certainty and seeming permanence of museological presentation, but even its actuality, through conservation, restoration, and other forces that forestall normal decay. In Africa, works of art are expected to change. Every time a mask performs, it may be repainted or given a new coiffure, a different costume, or a different wearer. And of course it is seen at different hours of the day and times of the year. This dynamic process is halted in a museum. If an African mask entered the museum at a moment when it temporarily had three

MICHAEL BRENSON: The permanent installation of paintings bothers me a lot less than the permanent installation of other cultures, of non-Western art. [A permanent installation of clocks and furniture wouldn't bother] me remotely as much. I mean it's very hard for me to be in the Rockefeller Wing.

JOHN CONKLIN: Matisse is performing. He was so exuberant that you can't believe he didn't want people to see and react like a delighted audience. You must have an audience. You must understand, feel, the energy of their act of seeing what you show them. I mean that must be for African art as well. . . . Bernini and the Baroque, everything was thought out in terms of performance, of affecting the viewer.

MAYA LIN: What has made me realize how [the building] works is watching three shows go in and out of it, knowing that they all are different. . . . And in a sense, the architecture goes away, and that was a very strong intention of mine. Because I would feel very uncomfortable if my architectural design got in the way of [the art]. . . . I don't want my aesthetic ego to color the art.

121

CAROL DUNCAN: A Western person standing in a Western museum looking at something in a case, or in a frame on the wall, that's been completely isolated, is also in a performance. . . . Except that . . . our sacred space . . . we don't admit is one. The terrible confusion is that we call it secular.

MAUREEN HEALY: One big consideration in my mind during the . . . installation of "Secrecy" was the balance with the new building. We talked about this: the idea of holding "Secrecy" back a little bit, not letting it fully spread its wings, because it would be competing too much with all that would hit people with the new building. It was the new location, it was the way that Maya had used the space, wanting to let [the design], the staircase for instance, be itself, wanting to showcase that a little bit, knowing that people would be taken with that space.

MAYA LIN: I ended up concentrating on threshold points, which you unconsciously pass through before you get to the art. I didn't really want to be in any way present when the art was present—but I'd be there to open the door, I'd be there to say goodbye.

attachments on the right and none on the left, that is the way it will be preserved. Constancy reigns in museums, especially in permanent installations, where the same light will shine on the object through all the hours of the day and all the seasons.

For the opening of "Exhibition-*ism*," this gallery will be installed by an invited group. On the first of every month the installation will change, following redesigns proposed by the audience (mostly classes and organized groups). The theme of the information and objects in this gallery will be death and commemoration. Writing materials for suggestions will be provided, and visitors will be furnished with a cabinet of reserve objects, blank floor-plans of the gallery, and a list of exhibition cases. The practical limitations will also be posted. The audience's installation plans will form part of the exhibition, and will be displayed. We hope people will come and watch the reinstallation each month, and will want to return to see how it looks later on. This process, of course, includes the audience in the most basic way. And it exhibits a variety of viewpoints, as earlier exhibitions have done, but in a new way.

1. Foreseeing relative inactivity in the areas of African-art exhibition and acquisition at the Metropolitan after the opening of the Rockefeller Wing, I began work on the creation of a new museum. (I remained on the staff of the Metropolitan part-time until the end of 1984.) The first meeting of the founding board occurred on March 21, 1982. It took two years to locate a suitable building, during which time the Museum incorporated (in July 1982) as the Center for African Art. A lease at 54 East 68th Street was signed in April 1984; the hiring of staff, the conversion of the building, and the creation of the opening exhibition and catalogue were completed in the next four and a half months. The museum opened on September 17, 1984.
2. These were "Treasures of Ancient Nigeria," organized by the Detroit Institute of Arts; "The Buli Master: An African Artist of the Nineteenth Century"; and "For Spirits and Kings; African Art from the Paul and Ruth Tishman Collection," all produced in the year and a half before the Wing opened in 1982. I am unaware of any African-art installation approaches of the time that were substantially different from those of the Museum of Primitive Art and the Metropolitan.
3. See *Perspectives: Angles on African Art* (New York: Center for African Art, 1987), pp. 29, 147. We published our exposure of the flawed process without comment. It inspired a long soliloquy on postmodernity, by Kwame Anthony Appiah (1992:137–157). This may be the place to record that the spirited sculpture of a Yoruba man with a bicycle shown on the cover of his book, and taken as his "touchstone," was probably made not "for the West," as he supposes, but as publicity for a Nigerian shop or small business. His quotation marks around phrases such as "authentically traditional" (p. 139) are unfortunate, since these are not my words.
4. Goldwater also wrote, "We must learn what we can of all these works so that we may learn to look at them. But finally what we know about them can only enrich, not fundamentally alter, our penetration of the emotional meaning of what they are" (Delange 1973:24).

5. For more detail on the installation of the Wing, see Vogel 1982.

6. The African area in the Wing is about 10,000 square feet and contains about 420 objects. The Center/Museum for African Art's exhibitions have included about 100 objects each, installed in about 3,500 square feet on 68th Street and 5,000 square feet in Soho.

7. The building conversion and the installation were designed by Maureen Healy. "African Masterpieces from the Musée de L'Homme" was curated by myself and Francine N'Diaye.

8. Healy was the exhibition designer of "Arts of the Guro," curated by Eberhard Fischer and Lorenz Homburger; "Igbo Arts," curated by Herbert Cole and Chike Aniakor, was installed by the present writer.

9. The installation was designed by Maureen Healy.

10. In the 1970s, Douglas Newton commissioned an artist to install a room in the Museum of Primitive Art that would evoke the torrential rains of New Guinea. The exhibition's objects—Washkuk pottery and other sculptures—were confined to the main galleries, while the last room downstairs was entirely filled by slender aluminum rods suspended from the ceiling and falling nearly to the floor at four- or five-inch intervals. The visitor could walk into the torrent and make his or her way through it, accompanied by the recorded sounds of Washkuk flute music. I remember it as incongruous but effective.

11. The installation design was by Maureen Healy, except for the diorama. "ART/Artifact" was curated by the present writer. I have discussed this exhibition in "Always True to the Object in Our Fashion" (1991); other writers on the subject include James Farris and Kim Levin in the second edition of the show's catalogue, published in 1989.

12. The exhibition designer was Maureen Healy; the photographer and coauthor of the book was Jerry L. Thompson; and I was the curator.

13. Much museum presentation is sleight-of-hand: what many visitors took to be lenses were in fact clear plastic napkin rings glued to the black metal sheets from photographic film carriers. These were clamped to the tension poles usually used to hold background paper. Jerry Thompson was the author of this ingenious arrangement.

14. Robert Farris Thompson curated the exhibition; Chris Müller was the exhibition designer. The installation conception and realization were also greatly shaped by C. Daniel Dawson. Lighting was by Russell Champa, "beach" by Darrel Maloney.

15. This thought was inspired by Barbara Kirshenblatt-Gimblett's description of the Museum of Jurassic Technology in her interview for this book.

Bibliography

African References

Arens, W., and Ivan Karp, eds.
1989 *Creativity of Power: Cosmology and Action in African Societies.* Washington and London: Smithsonian Institution Press.

Biebuyck, Daniel
1973 *Lega Culture: Art, Initiation, and Moral Philosophy among a Central African People.* Berkeley, Los Angeles and London: University of California Press.

Binkley, David A.
1990 "Masks, Space and Gender in Southern Kuba Initiation Ritual." In *Iowa Studies in African Art: The Stanley Conferences at The University of Iowa*, vol. III: *Art and Initiation in Zaire*. Christopher D. Roy (ed.). Iowa City: The University of Iowa.

Blier, Suzanne Preston
1989 *The Anatomy of Architecture: Ontology and Metaphor in Batammalipa Architectural Expression.* New York and Cambridge: Cambridge University Press.

Bravmann, René A.
1972 *Open Frontiers: The Mobility of Art in Black Africa.* Exhibition catalogue. Seattle: Henry Art Gallery.

Cole, Herbert M.
1982 *Mbari: Art and Life among the Owerri Igbo.* Bloomington: Indiana University Press.

Cornet, Joseph
1978 *A Survey of Zairian Art—The Bronson Collection.* Exhibition catalogue. Raleigh: North Carolina Museum of Art.

Denyer, Susan
1982 *African Traditional Architecture.* New York: Africana, and London: Heinemann.

de Surgy, Albert
1993 "*Fétiches II: Puissances des objets, charmes des mots*," special issue of *Systèmes de Pensée en Afrique Noire* 12.

Drewal, Henry
1977 "Art and Perception of Women in Yoruba Culture." In *Cahiers d'Études africaines* 68:17:545–567.

Drewal, Margaret
1992 *Yoruba Ritual: Performers, Play, Agency.* Bloomington: Indiana University Press.

Fernandez, James W.
1992 "The Conditions of Appreciation: Contemplating a Collection of Fang (and Kota) Mobiliary Art." *In Kings of Africa.* Erna Beumers and Hans-Joachim Koloss (eds.). Maastricht: Foundation Kings of Africa.

Fischer, Eberhard and Hans Himmelheber
1984 *The Arts of the Dan in West Africa.* Zurich: Museum Rietberg.

Gilbert, Michelle
1989 "Sources of Power in Aduropon-Akuapem: Ambiguity in Classification." In *Creativity of Power.* W. Arens and Ivan Karp (eds.). Washington, D.C., and London: Smithsonian Institution Press.

Glaze, Anita J.
1981 *Art and Death in a Senufo Village.* Bloomington: Indiana University Press.

Hoffman, Rachel
1993 "Seduction, Surrender, and Portable Paradise: Dogon Art in Modern Mali." In *Secrecy: African Art That Conceals and Reveals.* Mary H. Nooter (ed.). New York: The Museum for African Art, and Munich: Prestel Verlag.

Jonckers, Danielle
1993 "*Autels sacrificiels et puissances religieuses, le Manyan (Bamana-Minyanka, Mali).*" In *Fétiches II: Puissances des objets, charmes des mots. Systèmes de Pensée en Afrique Noire* 12:65–97.

Kopytoff, Igor
1986 "The Cultural Biography of Things: Commoditization as Process." In *The Social Life of Things.* Arjun Appadurai (ed.). Cambridge: at the University Press.

Lifschitz, Edward
1988 "Hearing is Believing: Acoustic Aspects of Masking in Africa." In *West African Masks and Cultural Systems.* S. L. Kasfir (ed.). Tervuren: Musée de l'Afrique Centrale.

MacGaffey, Wyatt, and Michael D. Harris
1993 "The Eyes of Understanding: Kongo Minkisi" and "Transformation, and Rhyme: The Art of Renée Stout." *Astonishment and Power.* Washington, D.C., and London: Smithsonian Institution Press.

Mack, John
1991 *Emil Torday and the Art of the Congo 1900–1909.* Seattle: University of Washington Press.

McNaughton, Patrick
1988 *The Mande Blacksmiths: Knowledge, Power, and Art in West Africa.* Bloomington: Indiana University Press.

Nooter, Mary H.
1991 "Luba Art and Statecraft: Creating Power in a Central African Kingdom." Unpublished Ph.D. dissertation, Columbia University, New York.
1992 "Fragments of Forsaken Glory: Luba Royal Culture Invented and Represented (1883–1992)." *In Kings of Africa.* Erna Beumers and Hans-Joachim Koloss (eds.). Maastricht: Foundation

Nooter, Mary H. (ed)
1993 *Secrecy: African Art That Conceals and Reveals*. New York:
 The Museum for African Art, and Munich: Prestel Verlag.

Peek, Philip M.
1994 "The Sounds of Silence: Cross-World Communication and
 the Auditory Arts in African Societies."
 American Ethnologist 21(3): 474-494

Reefe, Thomas Q.
1981 *The Rainbow and the Kings: A History of the Luba Empire to 1891*.
 Berkeley: University of California Press.

Roberts, Allen F.
1980 "Heroic Beasts, Beastly Heroes: Principles of Cosmology and
 Chiefship among the Lakeside Batabwa of Zaire." Unpublished
 Ph.D. dissertation, University of Chicago.
1992a "Chance Encounters, Ironic Collage." *In African Arts*
 25(2):54–63, 97.
1992b "Bugabo: Arts, Ambiguity and Transformation in Southeastern
 Zaire," and "Power Figures in Central Africa: Transition,
 Transversion and Process." Presented at a symposium organized
 by Dunja Hersak at L'Université Libre de Bruxelles.

forthcoming (a) "Ironies of System D." In *Recycled, Reseen: Folk Art from
 the Global Scrap Heap*. Charlene Cerny and S. Sheriff (eds.).
 New York: Harry N. Abrams Inc., Publlshers.
forthcoming (b) Entries in *The Encyclopedia of Vernacular Architecture*.
 Paul Oliver (ed.). London: Basil Blackwell.

Roy, Christopher D.
1985 *Art and Life in Africa: Selections from the Stanley Collection*.
 Iowa City: The University of Iowa Museum of Art.

Rubin, Arnold
1974 *African Accumulative Sculpture: Power and Display*. New York:
 Pace Gallery.

Schildkrout, Enid, and Curtis Keim
1990 *African Reflections: Art from Northeastern Zaire*. Seattle:
 University of Washington Press for the American Museum of
 Natural History, New York.

Simmel Georg
1978 The Philosophy of Money. (1907) Reprint ed. Boston:
 Routledge and Kegan Paul.

Steiner, Christopher B.
1994 *African Art in Transit*. New York and Cambridge:
 Cambridge University Press.

Thompson, Robert Farris
1993 *Face of the Gods: Art and Altars of Africa and the African Americas*.
 New York: The Museum for African Art, and Munich:
 Prestel Verlag.

Vogel, Susan
1986 *African Aesthetics: The Carlo Monzino Collection*. New York:
 The Center for African Art.

1991 *Africa Explores: 20th Century African Art*. New York:
 The Center for African Art, and Munich: Prestel Verlag.

Exhibiting References

American Association of Museums,
Commission on Museums for a New Century
1984 *Museums for a New Century*. Washington, D.C.: American
 Association of Museums.

Appadurai, Arjun (ed.)
1986 *The Social Life of Things: Commodities in Cultural
 Perspective*. Cambridge: at the University Press.

Appiah, Kwame Anthony
1992 *In My Father's House: Africa in the Philosophy of Culture*.
 Oxford: at the University Press.

Bachelard, Gaston
1964 *The Poetics of Space*. Trans. Maria Jolas; foreword by
 Etienne Gilson. New York: The Orion Press. Reprint ed.
 Boston: Beacon Press, 1969.

Barthes, Roland
1982 *Empire of Signs*. Trans. Richard Howard. New York: Farrar,
 Straus and Giroux, Inc., Hill and Wang. Reprint ed. New York:
 Noonday Press, 1989.

Baudrillard, Jean
1983 *Simulations*. Trans. Paul Foss, Paul Patton, and Philip
 Beitchman. New York: Semiotext(e) and Jean Baudrillard.

Boylan, Patrick (ed.)
1992 *Museums 2000: Politics, People, Professionals and Profit*.
 London and New York: Museums Association, in conjunction
 with Routledge.

Calinescu, Matei
1993 *Rereading*. New Haven and London: Yale University Press.

Cauman, Samuel
1958 *The Living Museum*. New York University Press.

Clifford, James
1985 "Objects and Selves—An Afterword." *In History of Anthropology*,
 vol. 3: *Objects and Others: Essays on Museums and Material Culture*.
 Madison: The University of Wisconsin Press. pp. 236–246.

1988 *The Predicament of Culture: Twentieth-Century Ethnography,
 Literature, and Art*. Cambridge, Mass., and London:
 Harvard University Press.

Cole, David
1975 *The Theatrical Event: A Mythos, A Vocabulary, A Perspective.*
Middletown: Wesleyan University Press.

Colomina, Beatriz (ed.)
1992 *Sexuality and Space.* Princeton: Princeton Papers of Architecture.

Crimp, Douglas
1993 *On the Museum's Ruins.* Cambridge, Mass., and London:
The MIT Press.

Delange, Jacqueline
1973 "Robert Goldwater and the African Object." In *Robert
Goldwater: A Memorial Exhibition.* pp. 16–20. New York:
Museum of Primitive Art.

Falk, John H., and Lynn D. Dierking
1992 *The Museum Experience.* Foreword by Willard L. Boyd.
Washington, D.C.: Whalesback Books.

Flam, Jack and Daniel Shapiro
1994 *Western Artists/African Art.* Exhibition catalogue. New York:
Museum for African Art.

Foster, Hal
1985 *Recordings: Art, Spectacle, Cultural Politics.* Seattle: Bay Press.

Foster, Hal (ed.)
1987 *Discussions in Contemporary Culture: Number One.*
Seattle: Bay Press, for the DIA Art Foundation.
1988 *Discussions in Contemporary Art, Number 2: Vision and
Visuality.* Seattle: Bay Press, for the DIA Art Foundation.

Francis, Mark, and Randolph T. Hester, Jr. (eds.)
1990 *The Meaning of Gardens: Ideas, Place and Action.* Cambridge,
Mass., and London: The MIT Press.

Freedberg, David
1989 *The Power of Images: Studies in the History and Theory of Response.*
Chicago and London: The University of Chicago Press.

Fried, Michael
1980 *Absorption and Theatricality, Painting and the Beholder in the Time
of Diderot.* Berkeley: University of California Press.

Harbison, Robert
1977 *Eccentric Spaces: A Voyage through Real and Imagined Worlds.*
New York: Alfred A. Knopf, Inc. Reprint ed. Boston: David R.
Godine, Publisher, 1988.

Hollier, Denis
1989 *Against Architecture: The Writings of Georges Bataille.* Trans.
Betsy Wing. Cambridge, Mass., and London: The MIT Press.

Karp, Ivan, and Steven D. Lavine (eds.)
1991 *Exhibiting Cultures: The Poetics and Politics of Museum Display.*
Washington, D.C., and London: Smithsonian Institution Press.

Katz, Flora
1984 "African Masterpieces from the Musée de l'Homme." In *African
Arts* 18(1):79–80.

Kirshenblatt-Gimblett, Barbara
1991 "Objects of Ethnography." In *Exhibiting Cultures: The Poetics and
Politics of Museum Display.* Ivan Karp and Steven D. Lavine (eds.).
Washington, D.C., and London: Smithsonian Institution Press.

Leyten, Harrie and Bibi Damen (eds.)
1992 *Art, Anthropology and the Modes of Re-presentation: Museums and
Contemporary Non-Western Art.* The Netherlands: Royal
Tropical Institute.

Napier, A. David
1992 *Foreign Bodies: Performance, Art, and Symbolic Anthropology.*
Berkeley, Los Angeles, and Oxford: University of California
Press.

Newton, Douglas
1978 "Primitive Art: A Perspective." In *Masterpieces of Primitive Art:
The Nelson A. Rockefeller Collection.* New York: Alfred A. Knopf.

[Povey, John]
1985 "The Center for African Art." In *African Arts* 18(2):66–67.

Preziosi, Donald
1989 *Rethinking Art History: Meditations on a Coy Science.* New Haven
and London: Yale University Press.

Price, Sally
1989 *Primitive Art in Civilized Places.* Chicago and London:
The University of Chicago Press.

Redford, Robert, Melville Herskovits, and Gordon F. Eckholm
1959 *Aspects of Primitive Art.* New York: The Museum of
Primitive Art.

Sayre, Henry M.
1989 *The Object of Performance.* Chicago: University of Chicago Press.

Schechner, Richard
1985 *Between Theater and Anthropology.* Foreword by Victor Turner.
Philadelphia: University of Pennsylvania Press.
1988 "TDR Comment." In *The Drama Review, A Journal of
Performance Studies* 32, 2(T118) (Summer):10–12. Cambridge,
Mass., and London: The MIT Press.

Sherman, Daniel J., and Irit Rogoff (eds.)
1994 *Museum Culture: Histories, Discourses, Spectacles.* Minneapolis:
University of Minnesota Press.

Smith, Barbara
1988 *Contingencies of Value: Alternative Perspectives for Critical Theory.*
Cambridge, Mass.: Harvard University Press.

Smith, Roberta
1987 "Art: Multiple Viewpoints in African Sculptures." In *The New York Times*, 23 October.

Stewart, Susan
1984 *On Longing: Narratives of the Miniature, the Gigantic, the Souvenir, the Collection*. Baltimore: John Hopkins University Press. Reprint ed. Durham and London: Duke University Press. 1993.

Stocking, George W., Jr. (ed.)
1985 *History of Anthropology*, vol. 3: *Objects and Others: Essays on Museums and Material Culture*. Madison: The University of Wisconsin Press.
1989 *History of Anthropology*, vol. 6: *Romantic Motives: Essays on Anthropological Sensibility*. Madison: The University of Wisconsin Press.

Stoller, Paul
1989 *The Taste of Ethnographic Things: The Senses in Anthropology*. Philadelphia: University of Pennsylvania Press.

Thomas, Nicholas
1991 *Entangled Objects: Exchange, Material Culture, and Colonialism in the Pacific*. Cambridge, Mass., and London: Harvard University Press.

Torgovnick, Marianna
1990 *Gone Primitive: Savage Intellects, Modern Lives*. Chicago: University of Chicago Press.

Tuan, Yi-Fu
1974 *Topophilia: A Study of Environmental Perception, Attitudes, and Values*. New York: Columbia University Press.

Vergo, Peter (ed.)
1989 *The New Museology*. London: Reaktion Books, Ltd.

Vogel, Susan
1974 "African Art: A History of Collecting." In *The Chase, The Capture*. New York: The Metropolitan Museum of Art.
1982 "Bringing African Art to the Metropolitan Museum." In *African Arts* 15(2):38–45.
1982 "Collecting African Art at the Metropolitan Museum of Art." In *Quaderno Poro*, 3 Milan.
1984 "New York: The Metropolitan Museum." In *Critica d'Arte* I(1) (Spring, second series):40–53.
1991 "Always True to the Object in Our Fashion." In *Exhibiting Cultures*. Ivan Karp and Steven Lavine (eds.). Washington, D.C., and London: Smithsonian Institution Press.

Vogel, Susan, ed.
1989 *ART/artifact: African Art in Anthropology Collections*. Exhibition catalogue, second edition, with additional essays by James Farris and Kim Levin. New York: The Center for African Art, and Munich: Prestel Verlag.

Walker, Peter, with Cathy Deino Blake
1991 "Minimalist Gardens without Walls." In *The Meaning of Gardens*. Mark Francis and Randolph T. Hester, Jr. (eds.). Cambridge, Mass., and London: The MIT Press.

Yamaguchi, Masao
1991 "The Poetics of Exhibition in Japanese Culture." In *Exhibiting Cultures: The Poetics and Politics of Museum Display*. Ivan Karp and Steven D. Lavine (eds.). Washington, D.C., and London: Smithsonian Institution Press.

Yates, Frances A.
1966 *The Art of Memory*. Chicago: The University of Chicago Press.

Contributors

Ayuko Babu, a consultant specializing in African cultural affairs, is Executive Director of the Los Angeles Pan African Film Festival. He served as curator of films for the 1993 African Marketplace, and film consultant to the Los Angeles Festival.*

Michael Brenson, a freelance art critic, historian, curator, and teacher, has written extensively on Western, African, and Asian sculptural traditions. From 1982 to 1991 he wrote about art for the *New York Times*, and in 1994 was the Visiting Senior Critic in the Graduate Sculpture Department at Yale University. In the Spring of 1993 he curated "Magdalena Abakanowicz: War Games" at P.S.1 Museum, and in the next year has two curatorial projects.†

James Clifford teaches in the History of Consciousness Program at the University of California, Santa Cruz, and is a historian and critic of anthropology and Western exoticism. Among his publications are *The Predicament of Culture* and *Writing Culture: The Poetics of Ethnography* (with George Marcus).†

John Conklin, a set designer for opera, ballet, and theater, has worked with, among many others, the Metropolitan Opera, the Chicago Lyric Opera, the Bastille Opera, the English National Opera, the Royal Swedish Opera, the Mark Taper Forum, the New York Public Theatre, and the American Repertory Theatre.†

Arthur Danto, the Johnsonian Professor Emeritus of Philosophy at Columbia University and art critic for *The Nation*, is the author of several books. His most recent publication is *Embodied Meanings: Critical Essays and Aesthetic Meditations*.†

Carol Duncan teaches art history in the School of Contemporary Art, Ramapo College of New Jersey. Her essays have been collected in *The Aesthetics of Power*. Her new book, *Civilizing Rituals: Inside Public Art Museums*, will appear in 1995.*

Ekpo Eyo, professor of Art History at the University of Maryland, was formerly Director of Antiquities at the National Museum of Nigeria. He was the vice-chairman of UNESCO's World Heritage Committee, and president of the Pan-African Congress on Pre-history. With Frank Willett, is the author of *2000 Years of Nigerian Art* and *Treasures of Ancient Nigeria*.*

Maureen Healy, the director of Healy/New York Inc., has been designing museum exhibitions for twenty years. Formerly designer at the Smithsonian Institution and the Metropolitan Museum of Art, she has designed many exhibitions for the Museum for African Art.*†

dele jẹgẹdẹ, art historian, artist, and critic, teaches art history at Indiana State University. Formerly Director of the Center for Cultural Studies at the University of Lagos and President of the Society of Nigerian Artists, he has published extensively on African art and has been featured in several one-man and group exhibitions.*

Ivan Karp, the National Endowment for the Humanities Professor and Director of Emory University's Graduate Institute for the Liberal Arts, is a social anthropologist with research interests in social theory, systems of thought, comparative philosophy, and museum culture. He is the author and editor of numerous books, including *Explorations in African Systems of Thought*, *Exhibiting Cultures* with Steven D. Lavine, and *Museums and Communities* with Steven D. Lavine and Christine Kreamer..†

Barbara Kirshenblatt-Gimblett, Professor of Performance Studies at the Tisch School of the Arts, New York University, was a Getty Scholar at the Getty Center for the History of Art and the Humanities (1991–92). She writes on exhibition theory and practice. †

Maya Lin, an artist, has produced public sculptures such as the Vietnam Veterans Memorial, the Civil Rights Memorial, and the Women's Table at Yale University. Recent works include "Groundswell," at the Wexner Center for the Arts, and "Eclipsed Time," a project for Long Island Railroad at Pennsylvania Station. Her architectural work includes designs for galleries, private residences, and, in 1993, the Museum for African Art. *†

Chris Müller, a theater and museum designer, is resident scenic designer for East Coast Artists and the Shapiro & Smith Dance Co. He has worked with the Welsh National Dance Co., Lincoln Center, the Joyce Theater, Julliard School, and Manhattan School of Music, among many others, and has designed exhibitions for the Smithsonian Institution, the Creative Discovery Museum, the Long Island Children's Museum, and the Museum for African Art.

Labelle Prussin, an architect and architectural historian, has held many academic appointments in the United States and abroad besides practicing professionally. She has conducted field research and published extensively on African architecture; among her publications is *Space, Place, and Gender: The Arts and Architectures of African Nomadism*. *

Jean-Aimé Rakotoarisoa, the director of the Musée d'Art et d'Archéologie at the University of Madagascar in Antananarivo, Madagascar, is an archaeologist and curator who has published widely on African cultures.*

Mary Nooter Roberts, as the Museum for African Art's Senior Curator, was responsible for, "Secrecy: African Art That Conceals and Reveals" and its catalogue. She has been a Visiting Professor of Art History at Columbia University, and consulting editor to *African Arts*. Following research in Zaire and Belgium, she was a fellow at the National Museum of African Art before recieving her Ph.D. from Columbia.

Enid Schildkrout, Curator in the Department of Anthropology at the American Museum of Natural History, New York, has been an Adjunct Professor at Columbia University and the Graduate Center, City University of New York. She has published extensively and curated several exhibitions on African cultures, including "African Reflections: Art from Northeastern Zaire."*

Robert Farris Thompson, Professor of African and African-American Art History at Yale University, is author of *Flash of the Spirit: African and Afro-American Art and Philosophy* and has written and lectured extensively on the endurance and evolution of African aesthetic and religious traditions. He has curated many exhibitions on African art, including "Face of the Gods: Art and Altars of Africa and the African Americas" at the Museum for African Art.*

Susan Vogel is the Founding Director of the Museum for African Art. She has done extensive fieldwork on the Baule in Ivory Coast. She recieved her Ph.D. from the Institute of Fine Arts and has served as curator at the Museum of Primitive Art, and the Metropolitan Museum of Art, where she oversaw the installation of the Rockefeller African Art collection. She has been named Director of the Yale University Art Gallery.

Fred Wilson, an artist who created the award-winning 1992 installation "Mining the Museum," critiques the museum environment in his work. He has had solo exhibitions at the Indianapolis Museum of Art, the Seattle Art Museum, the Museum for Contemporary Art in Baltimore, and the Museum of Contemporary Art in Chicago. In 1993 he represented the United States in the Fourth International Cairo Biennial in Egypt.*

*Participant in the Museum for African Art's May 1992 symposium, "Africa by Design: Building a Museum for the 21st Century."

† Interviewed by the curators in 1994.

Photograph Credits

"Exhibition-*ism*": All photographs by Jerry L. Thompson, 1993.

"Does an Object Have a Life?": Figs. 1 and 6, Susan Vogel; figs. 2, 5, 7, 8, and 9, Jerry L. Thompson, 1993–94; figs. 3 and 4, Allen F. Roberts, 1994; fig. 10, C. Daniel Dawson, 1993.

"Outside Inside": Figs. 1, 7, 8, and 9, Jerry L. Thompson; figs. 2 and 4, Mary Nooter Roberts and Allen F. Roberts; fig. 3, Susan Vogel; fig. 5, Allen F. Roberts.

"History of a Museum with Theory": Fig. 1, Jerry L. Thompson; fig. 2, Alfred Stieglitz; figs. 3, 4, and 5, courtesy of The Metropolitan Museum of Art, New York, Photograph Study Collection, Department of the Arts of Africa, Oceania, and the Americas, by Charles Uht; fig. 6, courtesy of the Metropolitan Museum of Art; fig. 7, The Living Museum: Experiences of an Art Historian and Museum Director, Alexander Dorner, 1958, courtesy Robert Reynolds.

"Portrait of a Museum in Practice": Fig. 1, Paul Warchol, 1993; figs. 2, 3, 4, 7, 8, 10, and 11, 12, 13, 14, 15, 16 and 17, Jerry L. Thompson; fig. 5, courtesy the Musée de L'Homme; fig. 6, courtesy of the Metropolitan Museum of Art; fig. 9, Christopher Roy, 1985.

The Museum for African Art
A Chronology of Exhibitions

1984

African Masterpieces from the Musée de l'Homme
Exhibition by Susan Vogel
Catalogue by Susan Vogel and Francine N'Diaye with an
Introduction by Jean Guiart
Traveled to: The National Museum of African Art

1985

Igbo Arts: Community and Cosmos
Exhibition and catalogue by Herbert M. Cole and Chike C. Aniakor
Traveled from the Museum of Cultural History, UCLA

Sets, Series, and Ensembles in African Art
Exhibition by George Preston
Catalogue by George Preston and Polly Nooter with an Introduction
by Susan Vogel

Arts of the Guro of Ivory Coast
Exhibition and catalogue by Eberhard Fischer and Lorenz Homberger
Traveled from the Museum Rietberg (Zurich)

1986

African Aesthetics: The Carlo Monzino Collection
Exhibition and catalogue by Susan Vogel

The Essential Gourd: From the Obvious to the Ingenious
Exhibition and catalogue by Marla Berns
Traveled from the Museum of Cultural History, UCLA

1987

African Masterpieces from Munich: The Staatliches Museum für Völkerkunde
Exhibition and catalogue by Maria Kecskesi
Traveled to: The Chrysler Museum, Madison Art Center

Perspectives: Angles on African Art
Exhibition by Susan Vogel
Catalogue by James Baldwin, Romare Bearden, Ekpo Eyo, Nancy
Graves, Ivan Karp, Lela Kouakou, Iba N'Diaye, David Rockefeller,
William Rubin, and Robert Farris Thompson, with an
Introduction by Susan Vogel
Traveled to: Virginia Museum of Fine Arts, Birmingham Museum of
Art, San Diego Museum of Art

1988

ART/artifact: African Art in Anthropology Collections
Exhibition by Susan Vogel
Catalogue by Arthur Danto, R.M. Gramly, Mary Lou Hultgren,
Enid Schildkrout, and Jeanne Zeidler with an Introduction
by Susan Vogel
Traveled to: Buffalo Museum of Science, Virginia Museum of Fine
Arts, The Henry Art Gallery, Cincinnati Art Museum,
Carnegie Museum of Art, Denver Museum of Natural History,
The Wight Art Gallery, Dallas Museum of Art

The Art of Collecting African Art
Exhibition by Susan Vogel
Catalogue by Robert and Nancy Nooter, Arman, George and
Gail Feher, Daniel and Marian Malcolm, John and Nicole Dintenfass,
Franklin and Shirley Williams, Ernst Anspach, Jean and
Noble Endicott, Gaston deHavenon, and Brian and Diane Leyden
with an Introduction by Susan Vogel

Africa and the Renaissance: Art in Ivory
Exhibition and catalogue by Ezio Bassani and William B. Fagg with an
Essay by Peter Mark and an Introduction by Susan Vogel
Traveled to: The Museum of Fine Arts (Houston)

1989

Wild Spirits Strong Medicine: African Art and the Wilderness
Exhibition by Susan Vogel
Catalogue by Martha G. Anderson and Christine Mullen Kreamer
with an Introduction and Edited by Enid Schildkrout
Traveled to: The Mary and Leigh Block Art Gallery, Lowe Art
Museum, Columbus Museum of Art, Worcester Art Museum

Yoruba: Nine Centuries of African Art and Thought
Exhibition and catalogue by Henry John Drewal and John Pemberton
III with Roland Abiodun, Edited by Allen Wardwell
Traveled to: Art Institute of Chicago, National Museum of African Art,
Cleveland Museum of Art, New Orleans Museum of Art,
High Museum, Phoenix Art Museum, Rietberg Museum (Zurich)

1990

Likeness and Beyond: Portraits from Africa and the World
Exhibition by Allen Wardwell
Catalogue by Jean M. Borgatti and Richard Brilliant
Traveled to: Kimbell Art Museum

Closeup: Lessons in the Art of Seeing African Sculpture
Exhibition by Susan Vogel
Catalogue by Jerry L. Thompson and Susan Vogel
Traveled to: Allen Memorial Art Museum, Arkansas Arts Center

1991

Africa Explores: 20th Century African Art
Exhibition by Susan Vogel assisted by Ima Ebong
Catalogue by Susan Vogel, Walter E.A. van Beek, Donald John
Cosentino, Ima Ebong, Bogumil Jewsiewicki, Thomas McEvilley,
and V.Y. Mudimbe.
Traveled to: The New Museum of Contemporary Art, The University
Art Museum (Berkeley), Dallas Museum of Art, Saint Louis Art
Museum, Mint Museum of Art, The Carnegie Museum of Art,
The Corcoran Gallery of Art, Center for Fine Arts, Ludwig Forum für
Internationale Kunst (Aachen), Fundació Antoni Tàpies (Barcelona),
Espace Lyonnais d'Art Contemporain (Lyon), Tate Gallery
(Liverpool) 1993

Secrecy: African Art that Conceals and Reveals
Exhibition and catalogue by Mary H. Nooter with contributions by
'Wande Abimbola, Kwame Anthony Appiah, T.O. Beidelman,
Suzanne Preston Blier, Michelle Gilbert, Barry Hallen, Rachel
Hoffman, Cesare Poppi, Nii Otokunor Quarcoopome,
Allen F. Roberts, Z.S. Strother, and Gary van Wyk
Traveled to: The Bermuda National Gallery, Virginia Museum of
Fine Arts, Walters Art Gallery, Des Moines Art Center

*Home and the World: Architectural Sculpture by Two Contemporary
African Artists*
Exhibition by Susan Vogel assisted by Bettina Horstmann
Catalogue by Ismail Serageldin, Celeste Olalquiaga, Jean-Louis Pinte,
and Jean-Marc Patras
Traveled to: The Contemporary (Baltimore)

Face of the Gods: Art and Altars of Africa and the African Americas
Exhibition and catalogue by Robert Farris Thompson
Traveled to: Seattle Art Museum, DuSable Museum of African-
American History, University Art Museum, Montgomery Museum of
Fine Art, Virginia Museum of Fine Arts

1994

Fusion: West African Artists at the Venice Biennale
Exhibition by Susan Vogel and Gerard Santoni
Catalogue by Thomas McEvilley
Traveled from the 1993 Venice Biennale

Outside Museum Walls
Exhibition by Susan Vogel and Carol Thompson

Western Artists/African Art
Exhibition by Daniel Shapiro
Catalogue by Jack D. Flam and Daniel Shapiro
Traveled to: Knoxville Museum of Art, Crocker Art Gallery